'Samantha Clark's lyrically written memoir is a sensitive and haunting account of what it is like to grow up with a mentally ill parent, and how it affected her family and own life. It is a powerful meditation about fractured relationships, human vulnerability and resilience, loneliness and death ... this unflinching memoir should appeal to those coming to terms with their own grief or mental illness'
The Lady

i

J

'A
sy
fe
cla
thi
bee
sen

and draw solace from'
Herald

THE
CLEARING

A MEMOIR
of ART, FAMILY and
MENTAL HEALTH

SAMANTHA
CLARK

ABACUS

First published in Great Britain in 2020 by Little, Brown
This paperback edition published in 2021 by Abacus

1 3 5 7 9 10 8 6 4 2

A CIP catalogue record for this book
is available from the British Library.

ISBN 978-0-349-14372-9

Typeset in Sabon by M Rules
Printed and bound in Great Britain by
Clays Ltd, Elcograf S.p.A.

Papers used by Abacus are from well-managed
forests and other responsible sources.

Abacus
An imprint of
Little, Brown Book Group
Carmelite House
50 Victoria Embankment
London EC4Y 0DZ

An Hachette UK Company
www.hachette.co.uk

www.littlebrown.co.uk

For Mark and Paul

CONTENTS

PROLOGUE

There are two endless directions. In and out.

Agnes Martin

When I was six years old my small world sprang wide open in an instant. I was sitting in the back of my parents' car, my father driving, my mother in the passenger seat. The trip must have been a fairly long one, because I asked fretfully, 'Is Scotland the biggest country in the world?' I can still hear my father's affectionate chuckle, and my mother saying, with a smile of amusement in her voice, 'No! It's one of the smallest!' Silenced by this astonishing revelation, I looked out at the passing fields and houses, straining for a sense of the real bigness of the world, stung and also oddly thrilled to realise my own smallness within it. The road hummed under the spinning tyres and my sense of myself shrank as I tried to feel how far everything around me expanded outwards in every direction, this world that was so much wider and grander than anything I had ever before imagined. I could feel it opening up inside me too, as my imagination stretched itself into all that space rolling outwards, on and on, far beyond the very farthest thing I

could see. Not long after that journey my mother got ill, and it seemed that we shrank our worlds down and folded in on ourselves. For a very long time I forgot the lesson of that day, forgot to be astonished, forgot that, at any moment, everything can just spring wide open.

In the summer of 2004 I arrived in Basel for six months on an artist exchange. I was in my early thirties by then, and had been cobbling together a rickety living as a visual artist for a decade, travelling from city to city to install work in art galleries or take up residencies, rushing back to Edinburgh during term-time for the two days a week of teaching at the art school that paid the bills. My mother's illness made her anxious and controlling, but my own busy life and frequent travel gave me a bit of space to breathe and be myself. For a good few years it was workable, even fun. But it was a runaround existence of cheap flights and long train journeys, so many arrivals and leave-takings that I was always homesick for somewhere, someone, or something. It might have looked, from the outside, like I had a moderately successful art career, but by the time I arrived in Switzerland with my laptop, camera and pocket German dictionary I was uncertain of myself, my work and the precarious, vaga-bond life I was living. It was expansive and full of challenge, but often lonely. Any glamour or adventure it might have once held for me had long since worn threadbare, and I had not yet found a way to achieve the more grounded way of life I was craving.

So despite the light-flooded, parquet-floored studio and

tastefully furnished apartment I was given for the duration of my stay, I was not sure why I was there. I had been introduced to a few other artists, but I did not feel a real connection to people or place, and in those first few weeks I mostly walked and cycled alone around the city, visiting its art galleries, getting my bearings. The steady daily practice of making art was the only familiar thing I had to hold on to, but I felt strangely disconnected even from this, like I was going through the motions. Money was short. Switzerland was expensive. I was spending more time alone than was good for me. There was a grumbling ache in my side, like a pulled muscle, that wouldn't go away.

My apartment building was next to a museum showing an exhibition of sculptures by Alexander Calder, delicately counterbalanced abstract mobiles suspended from the high ceilings that rotated slowly in the moving air. As part of the programme of events around the show, a performance was staged in the museum gardens every weekend – a high-wire act. I could watch it for free from my bedroom window, which looked over the wall surrounding the museum grounds. I would hear the melancholy violin music strike up from loudspeakers in the gardens, set aside whatever I was doing, go upstairs, lean on the sill of the open window and watch a slender man dressed in black, with what looked like ballet pumps on his feet, balance an extremely long, thin pole in his hands and, very slowly and gracefully, walk the length of a wire stretched between two high platforms.

My window was on the same level as the wire-walker and I could see his every movement, his dancer's wiry poise, his steady, inward gaze, the way he inched his feet so carefully

along the taut cable as it bowed under his weight. The slender pole he held lightly in his upturned hands flexed and twitched delicately, like an insect's antenna, as he felt the shifting air for the point of balance. I could hear, though not see, the audience watching below him, the chatter of anticipation as they gathered, the tense silence of collectively held breath as he walked his wire with no net to catch him, and the relieved applause when he reached the safety of the platform and turned to take his bow. An hour or so later, I'd hear the music strike up again and hurry to the window to watch him slowly climb his ladder, stand for a few moments to gather himself while the audience fell into a hush, and then step out onto the wire to perform his austere and stately ballet. Each time I watched I'd get that feeling where you suddenly fill up with a puzzling sadness and your eyes prick with tears, though you don't quite know why, only that a thing is beautiful and puts you in touch with something in yourself you hadn't been paying attention to until just that moment.

To get outside myself, to do something cheap and sociable, I joined some of my new Basel acquaintances for the annual Rhine Swim, when hundreds of participants climb into the river and are swept, in festive, chatting flotillas, right through the centre of town. As the swift-moving water bore me along with the other loosely clustered swimmers, I drifted past the wooden jetties for the little passenger ferries, past the medieval buildings and the modern office blocks, under bridges of stone and concrete. The river was deep and opaque, and its current was strong. I had no choice but to give myself up to its flow. Eventually I angled my

drift across the current towards the riverbank, scrambled up some concrete steps and made my dripping way home. But a few days after my float down the Rhine I sank abruptly. I woke in the grey dawn to find that the puzzling ache in my side had suddenly erupted, and it felt like hot lava was running inside my ribs. I could not catch my breath for the pain.

I was admitted, blue-lipped, to the local hospital as an emergency, hooked up to intravenous antibiotics, X-rays and ultrasounds were taken, a chest drain pushed though the cartilage between my ribs. A few sleepless nights and feverish days later I was lying on a gurney in my hospital room, waiting to be moved by ambulance to the main hospital in central Basel, as my condition had worsened. The fluid building up between my lungs and ribcage was not draining properly and a second, deeper chest drain needed to be inserted, this time thankfully under a general anaesthetic. Looking down at my pale, bony feet as they stuck out from the white sheet, I was reminded rather too strongly of Holbein's gaunt painting *The Body of the Dead Christ in the Tomb* that I had recently seen in the nearby Kunstmuseum. I managed to find this grimly funny, but I'd be lying if I said I wasn't scared waiting there, helpless and sore.

I needed to call my mother. I needed to call her now, before the surgery. Not to tell her I was ill, alone, afraid and in need of reassurance. I had to call her now because I was not sure I'd be able to sound normal if I called at the time we had previously agreed. By then I guessed I would be just coming round from the anaesthetic and I wasn't sure I would be able to speak. So I had to call my mother now,

while I could still manage to pretend that everything was fine. I was most certainly not fine. I was frayed at all my edges, sick and getting sicker. But if I missed our appointed time to call, her panic would be unleashed upon my father, upon my two brothers, upon the police, upon any friend or acquaintance whose phone number she could procure. I wasn't protecting her. I was protecting myself. I kept trying my parents' number, but couldn't get an answer. Eventually, I managed to leave a message that I was going to be out that evening and would call her the next day. I duly made the brief call the following evening, managing to sound more or less normal. I never told either of my parents what had happened.

Two weeks later I was discharged from hospital and deposited back in my studio. There was just a short time left to prepare for the open day that was part of the residency programme. I was still weak, thin, and shocked at my body's sudden collapse, but I wanted very much to leave illness behind me. With a sense of relief, new work came quickly. Too long confined by illness and convalescence, I wanted to bring the open outside world inside where I could reach it. I made big, fluffy cumulus clouds made of pillow stuffing and hung them from the ceiling, turning the empty white space into a cloud-filled sky. I covered the floor with filmy plastic dust sheets, taped them together into a kind of giant envelope and inflated it with an oscillating desk fan. The fine, silky membrane lifted off the floor and the big room was filled with the soft shushing sound and rhythmic movement of a slow ocean swell. Visitors came in and smiled, stayed a little to enjoy the drifting lightness of it all,

and talked with me about breath and space. For those two weeks I made my studio into an airy, oceanic dream world, and I rested there, regaining my strength and balance.

I began to realise that, one way or another, I had been making art about a kind of space between or clearing for years, always thinking about some kind of opening or pause taut with longing. I had made films of moths brushing against a window at night, drawn to a light they can't reach; recorded the crackling sounds of shortwave radio, half-heard music and voices speaking strange languages fading in and out of static interference; projected constellations of tiny midges against a black wall, so the wall dissolved and you felt like you were gazing into a starry void, except these weren't stars, just tiny insects, and you couldn't navigate by them. I had placed the delicate skeletons of migrating birds on clear shelves and lit them so you didn't see the bones, just the shadows of them spread across the wall. I had made art about the gap left when something is gone, about the feeling of reaching for something or someone you know you will never fully understand, about the shadow cast rather than the thing casting it, and the charged opening between the two.

In my notebook from that time, among the thumbnail sketches and to-do lists, printed in neat upper case in the middle of an empty page, are the words *THE SUBTLE ETHER*. It is a phrase, a question, a three-word poem that I have carried with me ever since. For years now I have been fascinated by the idea of a subtle ether that might fill the space between things. The ether was the pure, bright, upper air, filling the space between the stars and yet completely

undetectable, a hypothesis that nobody could let go of for centuries, despite a complete lack of evidence. A rarefied substance thought to permeate all of space, the ether was invented to fill all our emptinesses, an answer to a question we didn't yet know was the wrong one. The American poet Mark Doty says our metaphors go ahead of us, that they know things before we do, that a metaphor is a vessel that can hold thoughts that are too delicate or too charged to touch directly. The ether served me as just such a vessel, though I did not know to begin with quite what it contained.

When, a few years ago, my parents died within eighteen months of each other, I returned to clear the house that they had lived in for forty-five years. The past pressed in on me anew as I moved in those familiar, cluttered rooms in the company of my beloved and difficult dead. Going on ahead of me, as if to light my path, the subtle ether knew long before I did that for all the sadness that had pressed in on my family, making us small and cramped, angry and tight, there was a spaciousness, even here. It took three years to clear, repair and finally to sell the family home, longer still to for me to come to understand the depth of forbearance, patience and love that its rooms had held.

THE SUBTLE ETHER

We know whence comes our belief in the ether.
If it takes several years for light to arrive from a
removed star, it is no longer upon the star nor is it
upon the earth; it must be sustained somewhere,
and supported, so to speak, by some material.

Henri Poincaré

I have come, again, to the house I grew up in. It's a tall, narrow house in one of three identical streets of hand-some sandstone terraces built in the late nineteenth century. Once elegant, this area of Glasgow had become run down and soot-blackened by the time we arrived in 1970, when I was three years old. In those days middle-class families aspired to well-appointed suburban bungalows in wide, tree-lined streets, not the faded gentility of these narrow city terraces. When we moved here most of these big houses had been split into flats and bedsits, but ours was still a whole house. A crumbling Victorian beauty, it had high ceilings, ornate cornices and architraves, panelled doors, an elegant curved staircase, tall windows that rattled in the wind, anti-quated electrics and no proper heating. It was aspirational, a

financial stretch, and needed work. But after the first flurry of DIY, the work never got done. Because not long after we moved here my mother changed into someone none of us knew any more.

In recent years the street has become gentrified, the flats turned back into houses as families have moved back into the area. Outside what was once the corner shop, sleek-haired women with sleeping tots in buggies sip frothy coffee at pavement tables. The smoke-filled old men's pubs and betting shops have been replaced by trendy eateries serving avocado on artisan sourdough. The sandstone buildings have been cleaned back to honey-blond and shine a warm gold in the sun. Gleaming, oversized cars line the kerbside. I have to ease my way past their bulbous wing-mirrors that overhang the narrow pavement. The tall windows now afford glimpses of elegantly furnished rooms. But our house's state of disrepair reflects my ageing parents' slow decline, and its longer neglect by a family marooned on one overwhelming reality: my mother's long-term mental illness.

I slip the worn key into the lock, and as I open the door sadness clambers into me, as it always does when I step through this doorway. The roof leaks. Bits of ceiling have collapsed in unused rooms. Windows threaten to fall out of their frames. In the basement the walls are damp and the plaster is crumbling. I know all this familiar decay will be there to greet me as I enter. But this time something is different. This time my parents will not be there to greet me, because they are both dead. This neglected house now belongs to me and my two brothers. It is time to dismantle what remains of our parents' long life together here. The

task ahead of us is daunting. Nine rooms to clear, some stacked to the ceiling with nearly half a century's worth of upturned sofas, defunct televisions and old bicycles. We've hardly begun.

I clear a path through the accumulated junk mail on the doormat and the damp, fusty, pissy smells of the house fill my nostrils. I stand in the entrance hall in front of the door to the 'best' room, the room kept for visitors, the one my mother called the *lounge*. I reach to open the door, but pause, for in that small gesture another moment rises from the past to meet this present one. The same gesture, the same hesitation. I had come back to Glasgow for a weekend visit from London, where I was studying at the time. I knew things were bad at home. Not only was my father caring for my mother, he was also now looking after his own elderly mother. In her late nineties, my grandmother was frail and confused, no longer able to live on her own.

'Going home for some nurturing?' a friend had asked me the day before I caught the train north. I felt a cudgel of grief fall on me as I answered casually, 'Yeah, I guess so,' and changed the subject. If I tried to say more I'd feel the words swell and clog my tightening throat, hear my voice flatten and stall. It was too hard to explain. On the journey the next day a young woman was seated opposite me, next to an older woman, perhaps in her late forties; mother and daughter on an outing together. The younger woman leaned into her mother affectionately, seeking comfort. The older woman put an arm around her adult daughter's shoulder and cuddled her like a child as they chatted. From behind my book I watched the ease and love between the two

women as someone starving might watch others feast, until resentment overcame my fascination and suddenly I couldn't stand to look at them any longer. I moved seats.

When I arrived at my parents' home and went downstairs to the basement sitting room my mother was waiting for me on the edge of her chair, a cigarette clamped between her stained fingers, breathing fast as if she had been running. I knew she would have spent the last few hours chain-smoking and rocking in her chair, chanting doomily, 'She's late!', phoning the few patient souls who would still listen to tell them she was 'Worried to death!' about me. I could hear her lungs crackling in her chest. She looked unwashed, as if she had been wearing the same clothes for some time. Her hair was flattened on the side where she rested her head on the arm of the chair when she curled up, tight as a foetus, to sleep. Her skin looked grey and slack, and I guessed that she had not been outside in a long time.

'You're late!' she announced in her flat, loud monotone as soon as I came down the stairs. It was a familiar greeting.

'No I'm not,' I replied, irritated, in spite of my best intentions, by the sheer monotony of her dread.

Now that she had me in the same room, my mother was satisfied. She stubbed out her cigarette, curled up in her chair and sank away from us again. My father and I made small talk over mugs of tea that he had brought from the kitchen. I turned my cup in my hands, looking for a clean bit to sip from, took a deep breath and smiled at my father. He looked worn out.

'How's things?' I asked lightly.

'Oh, well, you know. Grannie fell out the bed last night.

I didn't think I was going to manage to lift her. She's a dead weight. Your mum's no help. Doesn't lift a finger.' My father cast a contemptuous look over to the other chair, where my mother was apparently asleep.

His real answer came later that night, when everyone had gone to bed. My father had taken to sleeping in the lounge, assembling a camp bed there so he could hear if my grandmother got up in the night and fell again. I lay awake in the damp of my childhood bed, worrying about how tired he was looking, how gruelling the responsibility was becoming for him, how my mother still oscillated between slurred sedation and breathless anxiety, how run down and dirty the house was becoming, how firmly my father resisted my attempts to bring in some help, how I could help them without losing my own hard-won freedom and tenuous happiness. Then I heard the sound.

At first I was puzzled. Then with a jolt I realised what I was hearing. My father was crying. It was a knotted, desperate sound. I could hear the pressure of grief behind the weeping he was trying so hard to contain that his sobs were tight, high pitched, muffled as if he were pressing his face into the pillow. It was the sound of desolation and it terrified me. I jumped silently out of my bed. I wanted to go to him. But I stood in the hallway in the half-dark, shivering, my legs shaking, my heart pressing at my chest as if to leap out and go to him, wanting to open the door but frozen to the spot, one shaky hand over my mouth and the other reaching towards the door handle, bare feet cold on the wooden floor. Two of us there in the half-dark with the closed door between us. How many nights had he

passed like this when I wasn't here? I listened as his weeping subsided, tears streaming down my own cheeks, and then crept back to bed, hunched under the bedclothes, cold to the bone. Eventually I must have slept. I never said anything. The next morning everything was as normal. We made chit-chat over toast and tea.

I leave the lounge door unopened again now and go on past it, down the stairs to the basement room where my parents spent most of their time those last years, watching television, dozing in their armchairs. I stand by my father's frayed and sagging chair. His absence from it pulls at me with the gravitational force of a black hole. I rest my hand where his head has left a grease mark on the fabric, breathing quietly while something heavy in my chest rises, turns slowly over and sinks away again. The ceiling above my mother's chair is stained brown with nicotine; she smoked a pack a day, often more. I look across to where she sat for so long, and feel my way back in time. An old heaviness comes upon me, a soft, wet weight like a pregnancy or a tumour.

My recall of the years I lived here with my parents is episodic, perforated with blanknesses and punctuated with bright vignettes of uncertain chronology, each one with its own peculiar density and saturation. Doors feature strongly. Slammed, or knocked gently on. Shouted through, or wept behind. What entered, or didn't. What stayed behind them. The chronic sadnesses of this house enter me along with the smell of stale carpet and unwashed clothes. My mother's lengthy absences from which she would return pale and chastened, duller and more docile. An illness I was never given a word for. The little brown pill bottles she

kept beside her. I'd pick them up to read the labels while she was sleeping, looking for some clue about what was happening to her, but the contents remained mysterious. Chlorpromazine. Temazepam. Largactil. The words tasted spiky, made me anxious. Too much x, y and z.

I drift from room to chilly room, stand in doorways with my coat on, staring at the piles of newspapers, the worn carpets, the old clothes heaped on unused chairs. The red light on the stairlift blinks silently. Here and there lie blister packs of pills, catheters in sealed packages, paracetamol and laxatives, the walking aids and ready meals I had brought as we navigated the slow emergency of my parents' last months together here. Time is halted in these rooms, as if unable to move on, snagged and tangled among the worn-out furniture and untidy stacks of magazines and unwashed clothes. In the kitchen, a grey dishcloth is draped over the tap, now stiff and dry, my father's stick still propped there by the sink, the plates and cups lying upturned on the draining board just as he left them. The walk-in cupboard is still stacked with the tinned food he hoarded, and the floor is piled with mummified shoes. It smells of the mildewed coats and waterproofs that have accumulated like stalactites, new on top of old, year upon year, on the big old hooks on the back of the door. I push the door shut. Even clearing out this one cupboard feels like an insurmountable task.

I go up to the rooms on the top floor, abandoned when my parents could no longer manage the stairs, and eye with caution the chunk of cornicing that threatens to come away from the ceiling above my head. My heart always beats a little faster when I come up here, and it isn't just the climb.

I get closer to something that frightens me when I am in this house, when I open the doors to its neglected, junk-filled rooms, something I would rather walk away from but know I can't. I unwrap the length of rope my father must have tied around the door handle of the back bedroom to discourage casual entry, a hollow feeling lodged at my sternum. In recent years I would wait until my parents had dozed off, then quietly creep up here to monitor the disintegration of the roof and windows, afraid after every winter storm that I might find a blown-in pane, a gathering puddle. Once this was my brother's bedroom. Long unused, it is now verging on dereliction. The plaster ceiling has caved in, punching a hole through the 70s polystyrene suspended ceiling my father had put up when he still had some enthusiasm for DIY. It now lies in a heap of rubble and horsehair on the floor. The faded curtains move gently in the draught from the windows that won't close properly now the frames are split and swollen with damp. They are so rotten I'm afraid to touch them in case they fall out. Across the landing is the bedroom my parents once shared. It must be more than ten years since either of them used it. Under my feet the pale bodies of dead moths lie in scattered drifts across the remains of the carpet. The room is now so full of discarded furniture and boxes I can't get much past the door.

I turn handles, open doors, close them softly, listening to the space of this house, noticing how it is all different now and yet the same as always. I have not lived in this house for thirty years, but this house still lives in me. Old loves, sorrows and fears move through me again as I walk these rooms. A letter from Glasgow City Council that arrived

shortly after my father died told us that major works needed to be carried out. There was, apparently, a maze of tunnels beneath us, shallow seams dug out in search of coal long before the street was built and never marked on any maps. We'd had hints before: a neighbour's garden shed had inexplicably flooded with black water; years ago, the gable wall of the house at the end of the terrace had leaned out over the course of several weeks, the family evacuated as the cracks widened, until it finally collapsed across the lane in a heap of rubble. The rooms split open like a doll's house, the heart of a family's home ruptured and exposed, the wallpaper streaked with rain, curtains fraying in the wind. Now, all these years later, the work to underpin the rest of the street's foundations is finally getting under way. The tangled shrubs in my parents' back garden have already been bulldozed, and the windowless wreck of the caravan we used to holiday in has been towed away and disposed of. A truck has been pumping vast amounts of concrete down deep drillings, into a hole located, it seems, directly beneath the foundations of our house. When I had first read the council's letter I thought, Yes. Of course. It made a strange kind of sense that we should have been hanging over a chasm hidden beneath the floorboards.

There is one room here that I have not entered for a long time. When he retired from his forty-five years as an engineer with the BBC, this room became my father's retreat and I did not intrude. I take a deep breath and pause, my hand on the doorknob, remembering my recurring dreams of this moment, dreams in which I open the door to find Poppy, the much-loved dog of my teenage years, waiting

patiently, starving and forgotten for decades, staggering to her feet to greet me lovingly, dreams from which I waken with a guilty, tender grief that sits upon me all day. Softly, I push, and go in. The chilled air smells of rubber cement and 3-in-1 oil. I tread carefully, sliding over magazines, envelopes and discarded shoes. Nearest the door lie bits of old tents, coils of rope, canoe paddles, oilskins, a canvas rucksack now stiff with mildew. Next to it, propped against the wall, are several cumbersome and mysterious structures of copper pipe, wire and dowelling, over six feet long and half as broad.

Working my way further in I reach my father's work-benches by the window. As I look around me, the clutter covering every surface begins to differentiate into recognisable objects: a radio transceiver, a Morse key screwed to the benchtop, Bakelite headphones, an ancient, yellowed BBC Micro computer, dog-eared copies of *Practical Wireless* magazine, padded envelopes spilling electronic components that look like beetles or sweets, enormous valves retrieved from decommissioned TV transmitters, crocodile clips and voltmeters, oscilloscopes and signal generators, batteries of every conceivable shape and size. The carpet by my feet is littered with tiny slivers of balsa wood, drops of solder, bits of plastic insulation stripped from electrical wire. My father's amateur radio licence is pinned to the wall, show-ing his call-sign: GM3 DIN. There are two sets of plastic walkie-talkies, the packaging still unopened. Face down on a 70s brown vinyl office chair lies a loudhailer, half-dismembered, spewing wires.

Stacked on the bookshelf are manuals on UHF/VHF

radio and building home-made antennae. The titles read *Out of Thin Air, Devoted to Low Power Communication.* Just so. Everything in this room is devoted to communication. But only at a distance. Only with strangers. While I was busy making my own adult way in the world, and while my mother, folded unreachably inside her illness and drowsy with medication, slept in her chair through decades of television, my father must have sat in here for hours with his headphones on, listening for voices riding carrier signals bounced off the troposphere, ghost voices sizzling through the static, transmitting little himself save a few pips of Morse to distant strangers known only by their call-signs.

The objects propped by the door, constructed from copper pipe, broomsticks and spirals of thick copper wire are, I now realise, home-made antennae. These ramshackle assemblages are, it seems, capable of picking up radio signals from the other side of the world, if conditions are right. With these antennae my father listened to the ether, for messages it might bring him. Once, while on an artist residency in Cambridgeshire, I stood in a field of placidly grazing cattle next to the radio telescope array at Barton and watched its rows of huge white dishes craning to the sky, like ears straining to hear the universe, the red shift of galaxies endlessly tumbling away from us in all directions. All at once, all together, they slowly and silently turned to face the same direction, as if they had heard something, perhaps the sudden burst of a supernova that exploded millions of years ago. The sight made my skin prickle. I waited there for hours, taking photographs, went back several times to try to film them, but I never saw them move like that again.

I couldn't hear what they heard, but I felt something in me opening into the distances they reached towards, as my father must have, as he tuned his radios and listened to the voices drifting in and out of the static hiss.

I pick up a handheld transceiver from my father's workbench, black and heavy, with a stubby rubber aerial like one of those early mobile phones, and switch it on. Unexpectedly, its battery still holds some power. The tinny speaker crackles to life then gives off a steady fizz of white noise. I wonder if some of it is cosmic microwave background radiation, a signal emitted uniformly across the universe at the same wavelength, the sound of photons from the Big Bang still cooling after fifteen billion years. I listen for a while, hoping that the soothing and miraculous sound of the beginning of the universe will steady me for the task ahead, but I find myself thinking about electronic voice phenomenon, when the dead are said to be heard speaking to us through the interference, and, spooked, I switch it off again. But I can't resist a mawkish 'Bye Dad. Ten four. Over and out,' as I do. Just in case.

This house was my parents' home for forty-five years, but mine for only fifteen of those. I left it as soon as I could and swam out into the world as if towards a lifeboat, went to art school, studied and worked in other cities, other countries, pressing myself outwards to escape my parents' orbit. But ties of love and obligation hold fast to daughters, and I came back regularly to visit. For the last few years, every other Sunday I would leave my home in Edinburgh after breakfast, take a bus, a train and then another bus, to make the two-hour trip to Glasgow, leaving in the evening

to make the journey back to Edinburgh. It was a tiring trip on top of my weekday commutes, but my parents had few other visitors, and guilt made me visit diligently, if joylessly, and more frequently the older they became.

This house has been a regular presence in my life for as long as I can remember. And for as long as I can remember my heart has sunk a little every time I walk in. The silence hoarded in its corners. The fear of opening, of falling. The television always on in the corner, its sedative blare covering everything over. The unseen mineshaft that had been under the floorboards all along. But this house is also the shape of love I grew up in; secretive, sad, tender, lonely. Love as the quiet preparation of a meal, the offering of a cup of tea, the small act of thoughtfulness that did not demand acknowledgement, did not expect return. This was my father's love, unspoken, unspeakable, as if speaking it would spell disaster, expose its tenderness to harsh light. My mother's love was trickier, a debt to be repaid, an uneasy deal struck after long and fractious negotiations, her anxiety my responsibility, an explosive panic hair-triggered to the clock and the telephone that defined our family life for decades. But it was love nonetheless, if a kinked and damaged one. And between these two people, now so present in their absence, my love for them both is still standing in a hallway, reaching for a doorknob, snagged on an instant, held taut between compassion and fear, a bruised softness lodged in the silences between words, behind the unspoken word *love*, in the hole in the middle of the 'o', pressing invisibly through the dark chambers of the heart, and lingering, still, in these empty rooms.

With the death of first my father, and now my mother, I keep finding myself turning back to the idea of the subtle ether. It's as if I am looking for something valuable I have misplaced. It seems there is something in the story of the ether that I need, but I don't quite know what it is. The nineteenth-century physicist, mathematician and philosopher Henri Poincaré believed that an ineffable ether filled apparently empty space because he thought that there must be something that sustained starlight during the long millennia of its invisible journey across the darkness of outer space. He didn't really quite believe the ether existed, but he liked the idea of it, because it patched the gaps in broken theories. It served his purposes. It must serve mine too, patch some gap or broken thing, a bodge job that keeps it all going, makes a flawed theory work. I like to think, as Poincaré did, that light from a distant star might be supported and sustained somewhere, even if I cannot see it, as it crosses unimaginable distances to arrive on Earth, perhaps after millions of years, to fall at last into the cup of my upturned eye. It's a hopeful thought.

The ether Poincaré wanted to believe in is an idea that has served humanity for thousands of years. To the Ancient Greeks, the ether was *arché*, the source, from which all substance, energy and motion comes into being. It was *to apeiron*, the boundless, everlasting and inexhaustible. An invisible yet incandescent ether, believed to be finer even than air, whirled around the Earth, snatched up stones and set them ablaze as stars. Aristotle decided that beyond the four earthly elements of earth, air, fire and water lay a fifth essence, the *quintessence*, an astral ether, remote, still and

perfect in the darkness beyond the moon, holding the stars in their fixed and proper place for all eternity. And there the ether stayed for two thousand years.

In the seventeenth century, when the universe was conceived as discrete objects scattered in neutral space, Isaac Newton's theory of gravity could only work if there were something filling the space between the apple and the ground on which it fell, between the planets as they followed their stately orbits, between the Earth and its faithful moon. Newton described light as made of tiny particles, corpuscles flung outwards from all shining things through the ethereal medium of God's sensorium. It was proposed that an ether wind passed unhindered through the structure of all things, through the atoms of whole planets like a breeze through a forest.

Michael Faraday, a scientist of the generation after Newton, was the self-taught son of a blacksmith, who got his learning from encyclopaedias and science books while apprenticed to a London bookbinder, and by attending the public lectures of the eminent chemist Sir Humphry Davy. He landed a job in Davy's laboratory when he impressed the older man with his copious and accurate lecture notes, and the doors of the establishment began to open for him. Faraday's questioning, experimental, intuitive intelligence flourished, as did his career, but he was always an outsider, not considered a gentleman by his contemporaries. He was not, like them, trained in Newton's advanced mathematics. But this turned out to be his great advantage. He did not inherit the assumption that space was neutral and uniformly empty, just an inert nothingness between solid

things that gravity and light somehow had to jump across. A devout, Quaker-like Sandemanian, Faraday believed that the divine presence was everywhere. He knew to look, not only at the things in his laboratory, but also at the space between them. He saw the way iron filings arranged themselves around a magnet and understood that supposedly empty space is not inert, but alive with fields of forces that threaded invisibly across it. Faraday had the insight that these electrical and magnetic fields were the unseen power that drove the unfolding universe. What mattered most was not visible matter, but what invisibly filled the space between, something he called force. We'd now call it energy.

In the nineteenth century the ether began to shed its aura of divinity and became a medium for the new scientific understanding of electricity, magnetism and, eventually, light. Light, conceived as either a wave or a stream of corpuscles, it was thought, could not cross a vacuum and so must propagate through some subtle medium: a 'luminiferous ether'. Throughout that industrious century of progress, physicists were busy searching for the ether. Theories were proposed and refuted, tweaked and rejected: the ether was stationary, or it drifted gently; it was a fixed and crystalline solid, or it stretched like elastic; it was viscous, like a clear jelly, as if the universe were suspended in aspic and light rippled through it like sunlight dappling through water; the ether was an 'imponderable fluid', or it was an electrical soup of jostling, spinning particles. Whatever its mysterious characteristics, the ether remained an article of faith, even when Albert Michelson and Edward Morley's most

infinitesimally refined measurements failed to detect it in their famous 'failed' ether drift experiment of 1887.

At the time, these two American scientists did not question the existence of an ether filling empty space. This was assumed. Their experiment was designed to measure only the speed at which the Earth drifted relative it. They prepared a highly sensitive instrument, mounted on a heavy sandstone block that floated in a bath of mercury in the basement of their university building in Cleveland, Ohio, which they hoped could measure the motion of the ether wind. However, their experiment found that there was no such motion. The ether wasn't there. But the implications of Michelson and Morley's data took another twenty years to fully sink in. The ether was only abolished from science with the birth of Einstein's 'space-time' in the early twentieth century, though Einstein too found it hard to let go of the subtle ether.

Physicists now tell us that the one constant in the universe is not the ether, but the speed of light. There is no place of rest from which to observe the motions of the universe, no home ground on which to stand, no absolute frame of reference, however ethereal, only the slippery probabilities of the quantum theorists and everything everywhere always in motion. Gone are the reassurances of the mechanical universe, where the planets spin their orbits like a clockwork orrery, against the backdrop of a celestial sphere onto which the stars are fixed eternally. Instead we teeter and whirl among non-linear feedback loops, iterated functions, strange attractors, hurricanes spawned from a butterfly's wingbeat, and dark energy pushing the universe outwards

as it goes tumbling away from us in all directions, faster and always faster. But still the ether haunts us. As cosmologists debate a 'quintessence' dark energy as a possible mechanism driving this expansion, the ether may yet make a comeback to scientific respectability.

For years now my thoughts have kept returning to this search for the ether, this unquenchable hope for a something-nothing that would fill the emptiness of space. Making and teaching art have been excuses to read and think about the ether. I have written scholarly papers on nothingness that have been published in obscure academic journals. I have learned to meditate, watching the space between my onrushing thoughts, and have sat cross-legged to receive teachings on emptiness from eminent Tibetan lamas. I have read what scientists say about light, and what might lie in the spaces between stars, and about dark matter and dark energy, floundering well beyond the edge of my ability to understand. My thoughts have craned towards mysterious immensities, the colossal expansion of the known universe, groping about for the ether, without ever really knowing what was driving it all.

But then my father died. And then my mother died. And I walked into their empty house and moved through its rooms, feeling out the space of an old and complicated sadness. I stood surrounded by my father's radio receivers and antennae, his walkie-talkies and loudhailers, with the insulated wires of my heart stripped bare by grief and sparking uselessly, and at last I made the connection – my father had been fascinated by the ether too, but we had never spoken of it while he lived. And I realised that the ether was a Trojan

horse, a way to approach something else by stealth. That really it was about my father. And it was about my mother, and how she was lost to me. How they were both lost to me. And it always had been, all along. It was about our circular orbits around each other, never quite touching, never quite pulling away. It was about the spaces between us, the spaces in this house, and what might be learned in them.

Here, in this basement, in the space between these two empty chairs and the people who once occupied them, is the space in which I grew to adulthood. And I realise that the task that lies before me is more than simply clearing away the remains of my parents' lives, more than sifting out the things of value from the old magazines and chipped crockery and sagging furniture. The task before me is to understand the elusive dark matter that lay at the heart of this home, the centre of its slow-spinning galaxy, to feel for its gravitational pull, the invisible ballast that, in spite of everything, held these two people together for sixty-eight years, and holds me in their orbit even now. The ether may be the space beyond the moon and between the stars, but it is also the space between the walls of this house, the space between the people who once lived in it, and what remains now they are gone. But, like the ether, this is something that can't be approached straight on. I must sidle up to it. Because the thing about nothing is this: to see it, you have to start with looking at things, and then look just off to the side of them.

A THEORY OF FLIGHT

The sky is the chief organ of sentiment.

John Constable

It's a rite of passage, clearing your dead parents' home. My two brothers and I pick our way through the dilapidated house where our parents raised us and grew old together. We have put off starting for months, overwhelmed by the scale of the task. Dealing with the accumulated stuff of our parents' lives is a creepingly slow process. We don't have a system. There is no room-by-room plan of action. We start haphazardly sorting what to keep, what to find a new home for, what to throw away. None of us seems to feel this is a task to be finished with brisk efficiency. It will take as long as it takes. There emerges between us an unspoken understanding that we each approach it in our own way and at our own pace. This is a work of mourning, not to be hurried.

We come when we can, after work, at weekends, trying to avoid being here alone after dark. My brothers both live quite near by and so their visits can, if necessary, be quick, impromptu, a drop-in just to check on things, to pick up a

29

carload for the charity shop or dump, or to take home for safekeeping. They prefer, when they can, to come together, to reminisce about the things they find and the memories they prompt, to cheer each other along and keep the ghosts at bay. I prefer to come here alone, to work in silence. If there are ghosts here, they speak, ever so quietly, through the objects I find as I work through the rooms. If there are ghosts here, I want to hear what they have to say. There are things I need to understand.

At least twice a week during term-time I make a long commute by train from Edinburgh to the university campus in the coastal town of Ayr where I am now teaching. It's a three-hour journey each way and my office, as often as not, is a laptop in a busy train carriage. I change trains at Glasgow, so every week or so I stop off en route and take the bus to my parents' house. It makes for a long day, but it might save me another trip at the weekend. It's a journey that I have made so often over the years that it feels like I must have worn a deep east–west groove between Glasgow and Edinburgh. At first I don't achieve much when I come, and perhaps I don't really aim to. Once I walk through the door all the rush and hurry of life outside can be held in abeyance for an hour or two. I move quietly, as if not to disturb something, though I don't know what, and slowly go through my parents' things. I might bag up some clothes or clear a shelf here and there, but often I pause and just listen to the quiet rooms, remembering. I am always drawn downstairs, through the basement sitting room, and through the door to my father's workroom at the back of the house, with the small, barred window looking onto the

overgrown garden. Here, in this room that only he used, I can feel the straightforward sadness of missing him, and I can understand this. It is almost comforting. The other rooms are more confusing.

Along one side of this room my father's amateur radio equipment lies still untouched on the long workbench. All along the other wall are stacked dozens of model aircraft wings. Each wing is carefully glued together from tiny struts of balsa wood across which is stretched a fragile membrane. One set of wings is spectacular, spanning a full ten feet, suspended diagonally across the ceiling. The others rest on pegs, in descending order of size. I lift one gingerly, blow off the dust, and my finger pops straight through the desiccated membrane. It is as fine and light as a bee's wing. The bodies of the model planes, to which these wings belong, are piled in a heap on another bench. Among them lie remote-control units with retractable aerials and levers. There must be dozens of models here. I had no idea he had made so many. I had hardly known my father fly them since I was a schoolgirl, but he must have kept on building them.

My brothers grew into their own adult lives before I grew into mine. Younger by five and ten years respectively, my childhood scarcely overlapped with theirs, and when my mother was ill I often spent time alone with my father. When I was about ten or eleven years old, I once stood with him in a broad, breezy field where men fussed and tinkered companionably with model planes, big ones, with intricate struts and blunt wingtips. All around us the little engines buzzed like angry bees, the tone shifting and juddering as the planes banked and turned following the twitch of

the levers on the remote control units the men held. These weren't toys. This I understood. My father's friend Murdo had the ends of two fingers missing and the blunt stubs of them fascinated me as he flicked the propeller to start the engine up, whipping them out of the way just in time. I don't think he actually did lose those fingers starting a model engine, but for me, the thought that he might have done gave the proceedings a buccaneering thrill of danger. I stood beside my father as he took up his remote-control box, placed a thumb on each lever and taxied the little plane over the tussocky ground until it lifted into the air with a fat rasping sound. I felt a great swooping inside me as he sent the model up high and far, a tiny black fleck in the bright and blowy sky, then I whooped aloud as he banked it steeply round to skim low and fast over the reedy grass right beside us.

My father would show me a cross-section of a wing and explain to me the theory of flight, how faster airflow across the upper curve of the wing creates lift, how, to be able to take off, a plane needs just the right balance between weight and lift, drag and thrust. Lift coefficients. Thermal updrafts and katabatic winds. How birds soar. I try to remember when he told me these things, but those moments are beyond recall now. I can hear his voice, explaining. I can see his eyebrows bristling as he squints into the light, as he points out something in the sky, a bird riding the rising air current on the windward side of a hill: 'Orographic lift,' he says. The words have stayed, the bird is still there, a soaring speck, but his voice, his face, his hand, pointing, these flash clear for an instant but then are gone. All I can take hold of now,

so carefully, is something about flight, about being in my father's room and him gone from it, a feeling that all these stacked wings give me, a feeling of catching a bird that's been trapped in a room, of a wren's panicky fluttering between my gently cupped hands, like holding a beating heart, and of opening my hands outside, and the small brown thing bursting from them to lift itself into the sky. He must have kept on building them for years. So many wings.

By the time I was in secondary school, I knew that the exams that loomed before me were my own capacity for flight, up and outwards into the world. They were also a good excuse not to come out of my room much, to avoid spending time alone with my mother. When I came home from school in the afternoons my mother had been at home all day and my father was still at work. I would drop my heavy schoolbag on the floor, greet Poppy, who came bounding to meet me at the door in a whirlwind of tail-wagging, and take her straight out for a walk, a good long one, right round the park, to fill some of the time until my father came home. It was a brief respite between the school day's social jostling and the heavy silences of home, when all I had to do to please was to throw a stick repeatedly, and Poppy's tireless, galloping joy and boisterous affection would revive my spirits for the evening ahead. But one such afternoon I came home to find my mother waiting, ready to intercept me. Her face had a hard, set look.

'Where are you going?' Her voice was sharp and suspicious.

'Taking the dog to the park.'

'You don't go to the park. I don't believe you. You're gone too long. I want to see where you go. I'm coming with you.'

I started to protest. This moment in the day was a precious, small independence and I was desperate to defend it. But I knew I could do nothing to stop her coming. When these dark imaginings came the force of her conviction would simply flatten everything in its path. I met her eyes with a furious glare, but her face was closed against me. She was looking right at me, righteous and wronged, but it was as if she did not see me at all. As I stood to confront her I felt as if I didn't even exist for her. I was less real to her than her own dread. I could shout until I was exhausted, try to reason with her, explain that her fears and suspicions were unfounded, but I knew that she would never hear me. The more I raged and shouted, the more her face would set with cold disapproval. She was in the right, and I was, always, wrong. My mother must have been planning this ambush, because she was ready and prepared, keys in her hand, as soon as I walked in. She had tied a scarf around her head in a way I hadn't seen her do before. Her tartan skirt hung loose around her, and she wore a quilted jacket that might once have been smart, but was now worn and grubby at the collar. It was an incongruous look, like the Queen out walking the corgis, only shambolic and crazed.

She couldn't keep me in the house with her all the time, safe from the all-pervading non-specific sense of threat that made every day seem fraught with dangers to her, but her efforts at curtailing and controlling my movements were relentless. I resisted with teenage rage and door-slamming,

but I had to choose these battles carefully. When I won some small freedom, say an evening at a schoolfriend's house or a trip to the cinema, the sheer effort of gaining it and the look of hurt betrayal in my mother's eyes as she curled back into her chair, begging me not to go and moaning with distress, sapped the pleasure from the occasion and left me drained. I would go anyway, to make a point, but would worry about making it home before she might get anxious again and start making phone calls to everyone she could think of, sweeping others into the momentum of her panic, calls that would later require my explanations and apologies. I lived in constant fear of her fear, second-guessing what might trigger it and trying to limit the damage it caused.

I knew I couldn't stop her following me to the park that afternoon. But I did not need to acknowledge her presence. I clipped the lead on the dog, pushed past my mother out of the door and walked quickly up the street, not looking back. I didn't want anyone from school to see me with her. I fixed my eyes on Poppy's cheerfully wagging tail as she tugged me along. We reached the entrance to the park and I realised my mother had already fallen behind. As we walked through the park gates, passers-by eyed her with concern. I glanced back to see her eyes darting around fearfully. Her mouth made strange chewing movements. I shortened my usual route, avoiding the steep path up the hill, but she was breathless and grey.

She had not been out of the house recently, not for weeks, as far as I remember. I did not have the words then that I have now – agoraphobia, depression, paranoia – to help me understand what she might have been experiencing. I found,

once, on a scrap of paper covered with half-scribbled-out, fragmentary notations of messages from saints and drawings of the cross, the words 'menopausal hysteria' written in my mother's handwriting and underlined several times. A phrase, I see now, archaic and fraught with misogyny, but at the time I had so little information to go on I fastened on to it as some kind of clue. I had only heard the vague term 'nervous breakdown' used to describe her illness. But a breakdown is an event. Something breaks down and is fixed, like a car. This breakdown didn't ever seem quite fixed. It just changed, sometimes turning inwards into sleep and silence, and sometimes, as now, turning outwards into these long drawn-out battles for control.

We reached the broad playing field and I set the dog loose to run. I wanted to run too, as far away from my mother as I could get, take flight, leave her far behind. I could have outrun her easily, just left her there in the park to make her own way home. She hadn't been eating lately, picking listlessly at the plates of food my father put down, while he scowled at her across the table, at as much of a loss as any of us. I scowled at her too. I learned not to see her, not to hear her, to build a wall and hunker down behind it, sullen and contemptuous. I had learned this from my father. It helped me get through the bad days. But looking back at her as she picked her way unsteadily towards me I saw her with a sudden fierce clarity. How frail she looked, and thin, unsteady on her feet, waxen pale and shaky, wild with fear. I slowed my pace. When she got closer I turned around and went on walking, but more slowly this time, worried she might fall.

As we came to the top of the wide, grassy slope that led down towards the park gates I stopped again, put the dog back on the lead and waited for my mother to catch up. When she came close enough she said with fierce conviction, 'You don't walk this far! You're trying to kill me!' I realised that she was right. What I wanted most in the world was for her to be dead, for her to be gone, for this whole sorry business to be finished, for her to be away from me for ever. But when I turned and saw her following me, I saw a pale and sick and frightened woman, whom nobody seemed able to help, whose loved ones hid behind a wall of contempt, and I realised with a rush of compassion that made the whole park seem to whirl, that what I longed for most was for her simply to feel safe in the world, and I could not make that happen.

I was just a teenage kid walking my dog in the park with my mother, but I roiled with feelings far too big and complicated for me. I almost retched with the strength of them, as if they were punching their way out of my body. Fear, guilt, fury, pity, love, grief, scalding shame. Most of all, fear, my mother's fear mixed with my own until I was no longer sure which was which. All I could do was to go on walking in silence, slower and slower, with my mother following behind, slower and slower, telling me again and again that I was trying to kill her. It seemed to last for ever, the three of us, a mother, a daughter and a dog, walking on and on in a slow-motion procession as the evening light dimmed, like climbers roped together as we picked our way down the slope to the park gates, between us an invisible force that both locked us together and kept us apart. On

and on I kept walking away from my mother. On and on my mother kept following me, across the drab, littered grass under the grey city sky.

The model planes are not the only flying things my father kept with his radios in his room at the back of the house. Lying amongst the debris on the floor is a large, rather battered wooden spool with a great length of strong white thread wrapped tightly around it, like a giant cotton reel. Nearby, I find a hand drill with a length of squared timber wedged into the chuck instead of a drill bit. The timber fits snugly into the centre of the spool. Together the two objects make, I realise, a kite string, enormously long. To keep us kids entertained during the holidays, my father would take a polystyrene ceiling tile from the pile that remained from an abandoned project, fasten a thread to each corner, fashion a tail of sorts from knotted plastic bags and launch the assemblage into the air attached to the long white thread. Even on a still day he could raise the thing until it caught the wind in the upper air, our faces all turned towards the kite as it lifted like a small white flower with a pliant, gracile stem, sprouting towards the light. My father would gradually unspool hundreds of feet of thread from the hand drill wedged at his belt, cranking the handle until the kite-tile was tiny with distance at the end of a vanishing swoop of thread. Then he would tie the line off and leave the kite hanging motionless up there, as if stitched to the sky. But is this just a story my brothers have told me, an old photograph I have seen, not my own remembering at

all but something borrowed? It's right at the far edge of memory, faint and uncertain. But still, the kite string holds my thought. What is a kite but a thing held taut between the fixed hand and the moving air? The kite only rises because it is tethered. Cut loose, it falls. But we fly them for the joy in it, because part of us lifts with the kite, even as our feet stay planted. I like the patina of the old wooden spool, the height coiled in the tightly bound thread. It has something of the sky curled up in it.

I stand quietly for a good while in my father's room, just taking it all in. It feels like being near him again. My father's room, behind an unlocked door that I did not push open while he lived. A room filled with longing and distance, humming with unheard transmissions, unspoken love and the dreamings of a man I hardly knew but had loved and depended on completely, and reach for now he is gone. A room of mute listening and grounded wings.

I touch his things, turn them over in my hands, set them down again. I remember how, when my father was becoming frail but still stoic, shrugging off my clumsy attempts to help as he carried on looking after my even frailer mother, I would find myself overwhelmed with tenderness whenever I saw an elderly man going slowly about his business. Like the old man beside me on the bus one day, who hoisted himself stiffly to his feet and waited, just in front of me, holding a bag of shopping with one hand and the other gripping the bar to steady himself as the bus swung to a stop. His hands, the paper-thin skin stretched over big knuckles, the liver spots and ridged fingernails, were my father's hands. His ear, his old man's ear, puffed and reddened and folded over

by his rough tweed cap pushing the soft flesh down, this old man's softly folded ear, grainy as orange peel and sprouting tiny white hairs, sent such a rush of tender sadness through me that tears began to well even though I knew they were ridiculous, I was ridiculous, weeping silently at the sight of a stranger's ear, on the bus, on my way home from work. As I hold my father's things now, I think of his hands moving over them, fixing, gluing, soldering, tinkering, making. I can't begin, this clearing-away of his things. Not this room. Not yet. I leave the room and close the door quietly behind me, find an easier job to do.

I am glad to get home to my own little flat. I shower, change out of my dusty clothes and put them in to wash. I sit down at the desk that takes up half the room and try to work. I have student essays to mark, emails to answer, a lecture to prepare, an early start tomorrow morning to catch the 7 a.m. train west again. But I find my mind drifting, seeking distractions. On the bookcase I keep a postcard artwork by Yoko Ono. It's a plain white postcard with a circular hole about the size of a fingertip right in the middle. To one side of it is printed 'A hole to see the sky through'. I have always kept it, propped here on the bookshelf, because I like it, because it reminds me of the artist friend who gave it to me who is no longer alive, himself now a hole where a friend used to be, and because, looking at, or sometimes through it, invites a certain tilt of thought, a lean towards unworded questions. A hole, pondered. I pick up the postcard and look through it, up at the sky above the slate rooftops. A white sky, a wintry flight-light, up and away. I press gently against the thought of all the wings my father

made, and what they show me of his inner life. The slope and lift of his thoughts. His dreams of flight.

As the years passed and I left home to build my own life, my mother's illness slowly closed around them both, two empty-nesters alone together again. At first, my father managed to get them both out of the house for day trips out in and around the city. Later, as they became less self-reliant, I was able to take a day off midweek now and then, and drive them out somewhere, down the Clyde, to the Ayrshire coast, to the Trossachs and Loch Lomondside, or just out for lunch somewhere. For a time, my mother was happy enough to come along on such outings. Then she stopped being able to control her legs very well and couldn't walk much, so she would wait for us in the car with the radio on, smoking her menthol cigarettes, while my father and I took a short walk or poked around some castle or museum. But when I started a demanding new full-time academic job I no longer had the flexibility to take time out midweek. My father didn't want to go out at the weekends. He said everywhere would be too busy. Our days out ended. Another small closing down, another shrinkage of their world.

My mother left the house less and less often. At first my father could leave her for a few hours, as long as he took his mobile phone with him, but my mother's always imminent panic controlled his movements more and more, until he couldn't leave her alone for longer than an hour or so. Once my father told me he had gone out and sat in the car, just to get out of the house, just to get away from my mother for a while. He sat for so long out there, parked in the street with the radio on, that a well-meaning neighbour knocked on

the window to see if he was all right. When he told me this I knew then how much of a prisoner he had become, held in the cell of my mother's illness. Its grip tightened slowly on them both as she became less involved with the world outside the house, less physically able, less communicative, her world contracting to her chair and the telephone beside it. My father did his sullen duty, dull anger lodged in him, a surliness towards my mother that I knew he moderated when I was there. Eventually, he hardly spoke a kind word to her, an edge in his voice like a knife when he addressed her. My mother got no smiles or human warmth, but food on her plate and the TV on. She closed in on herself, never said a word against my father, her loyalty unshakeable. My father did what was necessary, saw that she was fed and dressed. He was loyal too, in his own way. He stayed beside her, took the brunt, did what he could to protect my brothers and me from her grinding fear, from her need to control us, from the strangling tightness of it all.

Pain of any kind makes us small. A stubbed toe is enough: the mind shrinks down and fastens on to the pain like a limpet to its rock and doesn't want to let go. I watched their two lives fasten down and turn inwards. As my parents reached their eighties my father's once robust physical health began to deteriorate too. As they aged, it seemed as if the house was folding in on them, crumbling with them, its spaces filling up, closing in, and in those heavy years of everything sliding down I felt the growing weight of my own uselessness in the face of it all, as if I were tied to their sinking, everything getting heavier and heavier. I kept busy, pressing my attention outwards to a demanding job, taking

on a part-time master's degree and then a doctorate, getting promoted up the academic hierarchy, my days and my mind kept fully occupied. There was something frantic in all that activity. But at night I dreamed repeatedly of the house collapsing, chimney stacks crashing through the roof, windows falling out, glass smashing on the pavement, and somehow I was always to blame. The feeling stayed on waking, and it is a dark place in me still, a shame, that I did not have it in me to lift them up. But then the wings, yes, I think of my father's planes, and his kites, and of his radios, and of light and space and things that lift up and open out, because I do not want those other things now; the sinking down, the closing in, the cramped and the dark and the blocked-in things. They do not serve me now.

In his long, lyrical essay *Air and Dreams*, published in 1943, the French philosopher Gaston Bachelard meditates on the poetics of wings and the dream of flying. Trained as a scientist and known first as a philosopher of science, Bachelard turned later in his career to a very different way of knowing the world, through metaphor and imagination. He thought that imagination makes freedom and change possible, by allowing us to leave behind the ordinary course of things and 'launch out toward a new life'. The 'élan vital', the very impulse of life, was a travelling upward, a taking flight. Metaphors of rising, lightness, flight, height, Bachelard thought, lend the imagination suppleness and dynamism. As we follow with our eye the sweeping aerial curves of a bird in flight, we learn lessons of lightness, flexibility and openness to change, an airy dynamism that is not stormy or violent, Bachelard thought, but like a 'gentle

breath', the lightest breeze. The dream of flying has an aesthetic grace all of its own: 'To one who contemplates a graceful line, dynamic imagination suggests a most unlikely substitution; you, the dreamer, you are grace in motion. Feel *graceful power* within yourself. Become conscious of being a reservoir of grace, of being a potential for breaking into flight.'

As my father grew old and his health began to fail, he kept on making those wings and stacked them all away. Each wing he carefully crafted by hand, perhaps during a sleepless night or a long winter evening, from fine slivers of balsa wood and the glue he called dope, the papery translucent membrane delicately tensioned over the struts like a bat's wing over tiny bones. Each wing a private dream of grace in motion, his potential for breaking into flight. A reservoir of lightness. A home-made ascension. Daedalus built a labyrinth to imprison the Minotaur, and was himself confined in a tower with his son to prevent them revealing the labyrinth's secret. Daedalus made wings of wax and feather to lift himself and his child, Icarus, from this prison to freedom. We all know what happened to Icarus. But Daedalus? He made it, lofted himself to freedom, buoyed up on home-made wings that held him poised between the cold sea and the hot sun, and lowered him gently to the ground. I wonder if, in some private way, my father made it too, even as his body failed him, that something buoyant in him was able to rise, though tethered, like the kite on its string, becoming grace in motion. I hope so.

After a tiring week of work, commuting and clearing the house, I cycle to meet some friends for a weekend lunch

and some cheerful company. I cross over the low bridge at the docks near my home, over the slow water, enjoying the feeling of speed, legs pumping quick and strong, the cold air roaring in my ears. I hear a splashy clatter to my left, down below, on the water, and up it comes, a huge thing, dazzling white, hoisting itself improbably into the air, just skimming the chest-high parapet to cross the road right in front of me. I slam on the brakes. The swan's white neck reaches long and slender, the small head held steady as a gimbal, the big body lifting with effort, its back as broad as a pony's, the pinion feathers squeak-squeak-squeaking as it muscles through the air, pulling hard like an oarsman. And here now its mate follows, squeak-squeak-squeak, louder, closer, its wingtips almost brushing my nose. Could I climb aboard, quick as a flash, and go squeaking over the rooftops, my hands clasping that slender neck, legs tucked behind those broad wings? The thought lifts me up and I hear myself laugh out loud. A man walking towards me with his phone clamped to his ear ducks in surprise, stops, looks up briefly, mouth open, watches the swans go cruising past the bus stop and glide back down to land on the water, broad-bellied, skimming on their splayed feet, coming to rest among the half-submerged shopping trolleys, truculent gulls and bobbing footballs. The man looks down at the ground again, ear to the phone, talking, walks on. That night I dream breezily, swooping wingless among rooftops and chimney pots, witchy, gleeful, unseen.

INVISIBLE LIGHT

The invisible light can easily pass through brick
walls, buildings etc. Therefore, messages can
be transmitted by means of it without the
mediation of wires.

Jagadish Chandra Bose

As another winter comes around, my brothers and I
begin to feel like we are making some headway with
clearing the house. We remove our father's radio equipment
from his room and lay it out so we can see what we have,
what might be worth keeping, what someone else might be
able to use. The notepads of yellowing paper filled with cir-
cuit diagrams sketched in blue biro, the towering stacks of
old magazines and the piles of used envelopes tied up with
string are gathered up and taken for recycling. The radio
transceivers and antennae, the reels of copper and insulated
electrical wire of several gauges, the rolls of colour-coded
insulation tape and the sets of tiny plastic component draw-
ers labelled 'heat sinks', 'LEDs', 'misc. transistors', 'spade
connectors' in his careful handwriting are brought upstairs,
gathered into a bedroom we have managed to clear out, and

laid out on the floor in rows. There is a Morse key here, an old one with a Bakelite knob. It's a 'silent key' now, 'SK' in Morse, meaning 'end transmission', what radio amateurs call one of their own who has died. My father left all this gear to my brother, but his interest as a teenager has long since passed, and in any case he has no room for it. So I start to make enquiries, contacting amateur radio clubs, hoping to find a taker for at least some of it.

I take two old photographs home with me. They seem to tell me something important about my father, about the connection between us, about why the subtle ether still holds my fascination, and what it might have meant to him. They were taken on the last summer holiday I took with my parents, high on the hill above the campsite at Inveralligin, among the austere and timeworn mountains of Wester Ross. I must have been about fourteen or fifteen. My brothers were both old enough by then to avoid the family holiday, when for the first two weeks of every August we would tow the old caravan on a long day's drive north and pitch it a campsite that was really no more than a level, rushy bit of ground by a stream, next to a sheep fank, with a wooden honesty box nailed to a fence post that you were meant to shove a fiver into before you left. My father and I must have left my mother sleeping in the caravan one afternoon, snapped a lead on the dog, rock-hopped across the burn and headed up the rough hill track to where the views opened across to the mountains beyond Loch Torridon. My father always seemed to walk so tirelessly in those days. I tried not to show how I toiled to keep up with him, letting Poppy lean into her collar and pull hard to tow me up the steepest bits.

The first photograph, now yellowed at the edges, is of my father. I must have taken it, though I can't remember the moment. Behind him, the view is breathtaking, what tourists come to the Highlands to find. The sky is wadded with thick cloud over darkly humped mountains, ancient bones of the earth showing through a thin skin of peat and heather, above a sea loch as deep as a fjord. The distant hills to the west are ringed with sunlight and the shadow of a cloud drapes the highest peak like a dark cloth. Below, the loch gleams dull as pewter. But my father isn't looking at the view. Nor is he looking at the camera. He is pre-occupied with assembling long pieces of aluminium pole and dowelling, wire and red insulation tape. He's in a fraying cardigan and brown slacks, busy with his broomsticks and electrical tape.

A second photograph reveals the completed structure: a large, home-made antenna, or Yagi, angling towards the mountains. I think my father must have taken it. It's like many other pictures he took over his years working on outside broadcasts for television and radio, grainy black-and-white shots of boxy trucks with 'BBC' stamped on the side, parked on improbably steep tracks and hillsides, and of temporary dishes rigged up on mountain peaks or rooftops to bounce a television signal onwards. In those pre-digital days, radio and television signals had to be relayed like this by tall masts up and down the country. For outside broadcasts this meant dragging heavy equipment up mountains or on to the roofs of high buildings, with BBC 'links' vans parked near by, to bounce the signal, line of sight, on to the next link in the chain. Exploring how these signals travelled

was my father's hobby as well as his work, and carried on long after he retired.

The slender aerial he built and photographed here looks such a fragile and precarious instrument, blurring into the sky behind, its fine tips lost in the grain of the picture. The pole, wedged into the thin, peaty soil, is already starting to tip, perhaps catching the wind that so often scours those hillsides, and the whole apparatus points slightly skyward, slanted towards a clouded sky in a land worn to the bone. This ramshackle instrument, assembled by my father from aluminium tubes, copper wire and coaxial cable, lugs and gaskets, glue and solder, nuts and bolts, could do a marvellous thing. It could access something no human sense could reach, open up a part of the natural world that otherwise we would never come to know. Like a dowsing rod tuned not to underground water but to the subtle energies of the sky, my father's antenna could see invisible light. An antenna collects light just as our eyes do, but at wider frequencies, and the radio receiver, or transponder, turns this stream of light into sounds we can hear.

My father had brought a hand-held two-metre radio transceiver with him. In the first photo it is lying on the ground beside the box in which we had carried the antenna parts up the hill. The antenna in these photographs is a pricked ear, listening to the atmosphere for voices streaming through the clouds and bouncing off the mountainsides. I think we must have sat a while in the lee of a boulder, drinking tea from a flask while my father fished the skies for voices, hoping to catch fine slivers of sound that had travelled hundreds, perhaps even thousands of

miles, through the electrostatic swoosh and sizzle of the atmosphere.

He was fascinated with building and tinkering with these antennae, and with understanding the invisible geographies of radio signals as they travelled from transmitter to receiver in the real world of weather systems, sunspots and mountaintops. The two-metre band that he used is a portion of the radio spectrum that is allocated to amateurs. Its signal doesn't usually travel far, just a few miles or so, unless bounced onwards by a repeater station. But sometimes the signals can travel huge distances. The antenna my father used would, in reasonable conditions, have a range of about a hundred miles, but if the weather was right, a high-pressure system, say, then the signals could travel much further. Sunlight affected things too, changing conditions with the time of day and the turning seasons. So did meteor showers, distant lightning storms, solar winds and the sunspots that also cause auroras, and all for the same reason – electromagnetic changes in the Earth's high atmosphere. My father took his antenna up the mountain to test this out, and see just how far the space between transmitter and receiver might be stretched.

On the same holiday as this picture was taken, perhaps it was the day before, I had filled a jug with water, added a big dose of washing-up liquid, poured the mixture slowly onto a patch of sheep-nibbled grass near the caravan and waited. Moments later a dozen or so pink and writhing earthworms began to haul themselves up out of the soapy ground. I picked them up quickly and stuffed them into a coffee jar in which I had placed a handful of damp grass, pushed the

jar into my pocket and pulled a fishing rod out from under the van. The brown trout that lived in the Alligin burn were tiny, but delicious fried in butter over a campfire and laid on a slice of toast. Extremely shy, but worth the effort. You had to move slowly, watch your shadow didn't fall across the stream, and if nothing took a bite or you missed an exploratory nibble there was no point trying again at that spot. You had to keep moving, on to the next pool upstream, pushing through thickets of gorse and bracken, scrambling over wet rocks, as quietly as you could.

I started at the first pool, just above the campsite, adjusted the bubble float, put a worm onto my hook the way my father had shown me, wincing a little as I pushed the sharp barb through the worm's skin with a pop and it began to writhe and spin. I dropped the baited hook into the peaty current and let it be drawn past a likely looking eddy where I hoped a hungry trout might be waiting for a passing meal. I don't remember if I caught anything that day. Lacking both skill and patience, I never caught much. But it's not the catching that resonates all these years later. It's the waiting. No use plunging a hand into the cold, tumbling water, hoping to grab a trout up out of the flow. Nothing to do but stand, still and quiet, by the side of the rushing water, holding my rod gently, feeling for the quick, wiggling tug of a hungry brownie grabbing the worm, watching for the tell-tale bob of the bubble float, the brief, silvery flash of the trout's flanks under the dark water as it flipped against the hook. That waiting felt the same as this other waiting, with my father and his antenna. It had something of the same quality, a meditative drift yet alert to the catch of the

instant. A kind of calm longing that is not restless to be sated. Nothing to do but wait, a receiver tuned to an open channel. Up there on the windy hillside, we waited, my father and I, for a bright flicker of movement, a fragment of voice or pips of Morse, to materialise from the invisible depths of the sky and be reeled in.

Radio wasn't invented. It was discovered, quite by accident. Alexander Graham Bell's assistant, the talented young engineer Thomas Watson, was the first to hear the Earth's electric music, in the 1870s. Though they did not know of radio waves at the time, the sensitivity of the telephone device Bell and Watson hooked up to their test line, which made it possible to hear voices, also made it possible to hear radio signals for the first time, picked up when the half-mile of wire they had set up for their experiments in telephony acted as a low-frequency antenna. Among the dots and dashes of the telegraphers' Morse code signal, and in the silences between the spoken words, Watson described hearing mysterious snaps, crackles and something 'like the chirping of a bird'. After the day's work in the lab with Bell was finished, Watson would sit up alone in the stillness of the night listening to these sounds, wondering at their beautiful strangeness and speculating about their cause. Later, during the First World War, spies drove metal stakes into the ground next to enemy telephone lines and connected these to high-gain amplifiers so they could eavesdrop the audio signal. This worked well for the spies, but they found the voices swam in a sea of bubbling, crackling, chirping sounds, and an eerie falling whistle that they couldn't explain, a *peeow* sound they said resembled grenades flying.

Watson's speculations that the sounds might be caused by lightning, or even explosions on the sun, went unproven in his lifetime but turned out to be broadly correct. The telephone lines were picking up currents in the Earth's magnetosphere, storms on the sun frying the Earth's magnetic field, the swishing of auroras and the sputtering pops and crackles of lighting strikes. But the silence that allowed Watson to discover this faint electric night music was soon to be filled by the background hum of power lines as electrification spread rapidly. These days, this humming is so omnipresent that you have to travel far beyond cities and our man-made 'electrosmog' to hear the delicate and unearthly sounds of this natural radio.

We tend to think of radio waves as technological, but natural radio shows us that the electromagnetic world is as much a part of our environment as the water, the soil, plants and animals. Johann Wolfgang von Goethe claimed in the eighteenth century that 'Electricity is the prevailing element that accompanies all material existence, even the atmospheric. It is to be thought of unabashedly as the soul of the world.' Radio, visible light, infrared, ultraviolet, microwaves, cell phone signals are all part of the same electromagnetic spectrum. But because we can't see radio waves we forget that we are flooded with all this invisible light, even in the dark.

It was the Scottish scientist James Clerk Maxwell who, in the nineteenth century, first made the leap of understanding that linked electricity, magnetism and light. As a child Maxwell was said to be always asking the adults around him, 'What's the go o' that?' He never grew out of this

childhood curiosity, always trying to figure out what made things 'go'. Maxwell took Faraday's earlier insights into electrical and magnetic fields and explained them in the language of mathematics, and in so doing proved that light is an electromagnetic wave. Although less well known to the general public, Maxwell's work ranks with Einstein's in shaping our view of the universe. He opened the way for the era of wireless telecommunications that was soon to follow. Within a few decades of Maxwell's insight, Guglielmo Marconi was transmitting radio waves across the Atlantic.

Maxwell saw light as a vibration, a wave of energy, and supposed that, like waves in the sea, these waves must travel through some medium. Like those before him, he used the term 'ether' to describe this medium. But Maxwell knew the ether was just a convenience. It was, he wrote, 'a collection of imaginary properties' whose role was to assist the imagination. 'I do not bring it forward as a mode of connexion existing in nature, or even as that which I would willingly assent to as an electrical hypothesis.' Instead, 'it serves to bring out the actual mechanical connexions between the known electromagnetic phenomena'. For Maxwell, then, the ether was not something that existed in and of itself but something he used to understand the nature of light. His ether was a thinking tool he used to help him understand something else, a bridge that crossed the gap between the things he did understand, so that the questions he could not answer did not stop him in his tracks. The ether helped him to keep going in the face of uncertainties and unknowns. It gave them a name, a set of given properties.

My ether, too, is an idea that bridges an uncertain gap,

gives me a name and set of properties for ... what? For long-ing, I think, longing for the father I knew but didn't know, for the mother who was taken from me by her illness, and for all that I will never know about either of them.

As I sit here in my own home, lost in thoughts of light and loss and longing, the winter sun puts in a bit of extra effort as a cloud slips by. Sunlight fills my small room with a lemony glow. It lifts me every time, this light. It feels like kindness. Something gentle and most welcome. The cloud has opened up a little and the nine bright squares of the windowpanes are beaming in like searchlights. Sunlight rakes across the wall, the same nine window-squares now slanted, stretched into long rhomboids, slipping over the radiator and the chair, reaching towards the floor. So very ordinary, this daily blessing of light, and yet not ordinary at all, because what I am seeing is utterly strange. Photons, the stuff of light, are the strangest thing imaginable, indeed scarcely a thing at all, because they are nowhere until seen, erupting into visible light only when they meet the eye. Light is the fastest thing in the universe. Nothing else trav-els quite like light does; no matter the speed of the thing emitting the light and no matter the speed of the observer, the speed of light is always exactly the same. You can never get any closer, nor any further away from light. It always outstrips us by exactly the same interval, like a horizon that takes one step back for every one we take towards it. Nothing with mass can match light's speed, and, because of its speed, light is everywhere, all the time. As Einstein explained, light, travelling at such blinding speed, collapses time and everything is here and now, always. This is how

Tibetan masters describe the view enlightened beings have of the universe. All times, all places, are here, now, for ever, timeless. Time and distance lie spooled inside each photon. Perhaps to be enlightened is to see the universe, as Einstein dreamed, as if astride a beam of light, riding a photon. And yet here it is, winter light, flooding my lap, pouring its milky chill over my face.

Does light cause the eye that sees it, or does the eye cause the light it sees? The eyes in our heads evolved over millions of years, ripening like berries in the patient sunlight. Goethe said 'the eye is formed by this light for the light so the inner light may meet the outer; for if the eye were not sun-like how could we perceive the light?' There is light inside the eye too, known as entoptic light. Cave explorers and volunteers in laboratory experiments report that even in perfect darkness they see spots and sparks of light. These lights appear when there is nothing left to see and so the brain invents 'dark noise'. If you press your fingers to your eyeballs you can watch the kaleidoscoping phosphenes exploding in the dark. And it's not just the retina that receives light. There are rods and cones in the skin too, on the back of the hand, in the cheeks, the forehead, the top of the head. The skin ingests light as vitamin D. Light is food.

The light in my room becomes clouded, diffuse, washing the wall, floor, the desk, my hand, in pale luminescence. The cool light of the north in winter has this flatness to it. Not blaring. Soft, grey at times. Dull, you might say. But wait, see how the white things, the blue things, glow within it? A clump of early snowdrops fluoresces at the base of the bare birch tree in the car park outside my window. A scrap

of white paper enunciates crisply among the browns of the dead leaves. A blue sweet wrapper vibrates in the drain. Less light per square metre, my father would explain to me, because we are aslant to the sun, here in the north, in winter. Here in Scotland the winter light is so thinned out it is the only time of year it is safe for the National Gallery to bring out the fragile Turner watercolours from the vaults and put them on public display. When I remember this, I decide to go to see them right away, as I realise that very soon they will be stored away for another year. I have a question for them, but not one that can be held in the mouth, or on the page.

It's a still, damp afternoon as I make for the bus stop. Everything's sluggish under a sky that now looks heavy with rain. I stand at the bus stop in a dim boredom, watching the gulls bob about on the black river water like they just can't be bothered to fly. People on the bus stare blankly out of the windows. No one is talking. I take a seat on the upper deck and rumble along, surveying the street from a lordly height. As we pass the fish shop I look down on pale arms reaching towards a row of gelatinous pink fillets laid out on trays of chipped ice in the brightly lit window. The pavement is speckled with constellations of gum. The dark paving slabs look slimy, though it's not raining, yet. Men smoke side by side in pub doorways, staring at the street, or wait for buses with their hands in their pockets. Someone at the back of the bus is listening to the football commentary, his phone on speaker. Two women pass by, walking briskly down the street, one carrying an enormous brown toy dog wedged under her arm. Its legs flail as she walks and its lolling pink

felt tongue almost licks the wet pavement. Everything is doused in the deadpan light of a winter afternoon.

When I arrive in the dimly lit room of the National Gallery, the paintings are hung, well spaced, against a bottle-green wall. Visitors in smart overcoats gather in front of them, speaking to each other in a reverent hush, moving across the dark carpet like grazing horses, serious, slow and purposeful. This collection of watercolours comes out of storage for just one month each winter, and here is the one I wanted to see again. I smile as if I've caught sight of an old friend. Glowing in the dim lighting against the dark wall is *The Grand Canal by the Salute, Venice*.

In this small watercolour, the huge stone basilica seems to dissolve in the Venetian light. It isn't solid any more. It hangs like luminous backlit gauzy curtain in the heat and light. The stonework is bleached away, as if become light itself. The shadowed canal, the paved ground, everything is hovering. What was it I wanted to be reminded of? How a shift of light can either thicken things, coagulate the density of their surfaces, or it can open them up, thin them to this translucency? How the thingliness of things, their opacity and certitude is so ... contingent, suspended somehow? Here in these watercolours the sandstone buildings of Venice, the rocky mountainsides of Austria and Scotland, are all dissolving away, becoming incidental to the main story of light and its movements, the movement of the painter's hand, delicate yet swift, the brushwork scumbling fast while the paint's still wet, showing his workings, wash over wash, his thinking through the brush and pigment. And the rough surface of the paper, it too dissolves, that old magic trick of painting,

the flat plane becomes a window opening into a deep space, the paper's surface just a veil to pull aside and step through.

I have come late in the day and the gallery is closing, but that's okay. I just wanted to visit briefly, greet these paintings as I like to do every year, before they are returned to the dark vault safe from the ravages of ultraviolet light. They give some kind of reassurance of continuity, like the return of migratory birds. The paintings too seem to have come from far away, gold-lit, carrying the warm south and the promise of spring among their pinions.

It had been raining heavily while I was inside, but the clouds have cleared now. I need some fresh air so I decide to walk home. Still carrying a lingering afterimage of Turner's luminous watercolours, it's as if, just for a while, I am seeing the familiar streets of Edinburgh with his sun-like eyes. The very last of the winter sunlight is slanting low and bright gold among the sandstone buildings. A row of shadow chimney pots is thrown across the gridded astragals of the windows across the street, its glass panes a dazzling gold. A lamp-post casts darkness instead of light, its shadow a hundred feet long, running right down the shining, wet pavement and crossing the path of a bald man out walking four French bulldogs on four multi-coloured leads who are tugging him along like a charioteer. Burnished by the light of this low winter sun, Edinburgh seems miraculous, a strange, luminous city.

I walk these long-familiar streets towards home, drenched in winter sunlight, groping to understand something about light that seems important, thinking about Turner's dissolving, translucent painting that never quite settles as solid

stone or lambent light, thinking about my father's antenna picking up distant light that can't be seen, thinking about how this glistening pavement, this cold light bouncing off the passing cars, this deep blue sky above, this pale-faced young man walking towards me, earbuds filling his world with music I can't hear and his own thoughts turning, how all of these so utterly exceed everything I can ever know of them. If I paid proper attention, I should be awestruck, every moment, by the sheer grandeur and mystery of each dazzling, light-struck puddle, each tender human face on the street around me. No matter how many questions we ask, what measurements we take, how sensitively we calibrate our instruments, what data we gather, however much we might desire to, we can never completely know the world, nor anything or anyone in it. We see such a small slice of reality. The visible world is a veil, and yet it's also our only way in. Our knowledge can only ever be partial, fleeting and provisional, as the world rises to meet us, breaks over us and slips away, moment by moment. Everyone I walk past on this city street has lost or will lose all that they love, and every single one of us is dying even as we live. Every moment is always falling away from us and we can keep hold of none of it. The world exists for its own reasons and owes us no explanations. We can only lean towards it in longing, even as we have to let it go. Perhaps all of living is rightly seen as a work of praise and mourning, as each shining instant flares then blinks out into dark.

When I get back to my flat, the two photos of my father and his antenna are still lying on the desk where I left them, two small, rectangular punctures in time and space, old

light held still in yellowed photo emulsion, like a fly caught in amber. I can't even remember that day on the hill now, beyond some quality of the Highland summer light, my wet boot stepping in a stream, the sharp tang of sheep dung. And yet these two photographs show that my father and I were both there that day, me invisible behind the camera on the windy hillside, my father pictured in one photograph, his finished antenna in the centre of the other. On the hill with my father, in the light and the wind, looking out over the loch below us, I'd have been passing the time while he tested the farthest edge of his antenna's reach. Poppy would have been near by, dragging herself across the scratchy heather giving little grunts of pleasure or begging for a biscuit. My father would pull hard-boiled eggs from his pocket and hand one to me, with a pinch of salt in a little twist of foil to dip it in. High on the hillside, with the wind freshening and the sky of silvered clouds opening chinks to blue beyond, Poppy leaning into my legs companionably, I felt safe, there, with my father.

Always in the same battered canvas shoes and navy blue BBC-issue anorak, he was casually competent in the out-doors, no swagger or machismo in him, no fancy outdoor gear, no peaks to conquer, nothing to prove, just a plain, matter-of-fact at-home-ness. He was good at finding the right path, at naming the mountains we could see around us, at getting a campfire lit and a slice of bacon frying. He was born and spent his early childhood in Canada, where my grandfather, like many adventurous lads from north-east Scotland, had gone out to work for the Hudson's Bay Company. The wide, open spaces of Manitoba, where lake

and forest stretched to the horizon, lived on inside my father long after the family left to return 'home'. He often spoke of those vividly remembered times, poring over tiny, fine-grained black-and-white photographs of himself there as a small boy, bundled in furs in a sled pulled by dogs, with snow and forest all around, or in shorts and sandals, squinting in that northern summer sunlight, on picnics by a shining lake. He was brought back to Scotland in 1932, aged just six, to a flat above a shop in Aberdeen. It was a wrench of lost freedom I think he always felt, and spending time among mountains and lochs was a salve to him.

My younger self and my living father were together that day among the boulder-strewn heather on that mountainside long ago, our bodies and minds burning like well-stoked furnaces, just like the surging world around us; the wind brawling in from the west, the wild creatures moving unseen over the land and through the water, the tide sucking in and out of the deep loch far below, the Atlantic weather systems pushing low cloud over the horizon, the mountains eroding, the rocks weathering, and my father's radio crackling and hissing with the electromagnetic movements of the high atmosphere, the sunspots and solar winds, the sizzling ionised tails of falling stars, and all the falling days, all my days since that one falling, and my father's days all now fallen and gone. The dizzy days flash and fade quick, like sparks, and my father is listening still, with his headphones on, he is listening, aiming his antenna between the mountains, listening into the distances, listening out for light's faint voice. I thought my father's love of radio was all tinkering and technicalities, but what I see now is his

longing, and my own longing answering him. The past is real, but always out of reach. I turn towards it, listening, craning to hear, but I cannot take even one step closer. My heart listens out for him, but I have forgotten that day my father and I spent together, that and so many others. What's left is atmosphere.

EVENING

O Evening Star, bringing everything
that dawn's first glimmer scattered far and wide –
you bring the sheep, you bring the goat,
you bring the child back to the mother.

<div align="right">

Sappho

(Trans. Gillian Spraggs)

</div>

More than a year and a half has now passed since we began clearing out our parents' house. The invisible hole of the old mineshaft deep beneath it has now been filled in. The heavy trucks and pumps have gone from the back garden, the thicket of sprouting birches has been removed, new turf laid over the muddy ground. There is now a smooth lawn and a neatly slabbed path to the back door. The house has been re-roofed too. It was a job that couldn't wait until the place was emptied. The joists had become so rotten that in some parts it was only the tension of the interlocking slates that was keeping the roof up, and another winter's storms and snowfall could have been disastrous. So, although we would rather have waited until the house was a little more presentable before allowing strangers in to

witness the dilapidation and the dirt, we had to act quickly to fix the roof. Scaffolding went up over the summer. Rotten timbers were replaced, slates re-drilled and nailed back into place, leaks plugged, tradesmen coming and going with boots and bustle.

Now the workmen have started pulling out the damp plaster in the basement. It crashes from the walls in great heaps, raising clouds of dust. They have the radio on loud and the old smell of the place has been replaced by the sharp reek of damp-course chemicals. The house has become even more of a jumble than when we began, everything coated with a thick layer of plaster dust, cupboards pulled open and drawers rifled through, black plastic rubbish bags in bulging heaps. But the space has started to tilt now, away from the past and towards the future. I still feel the loss of my parents, of course, but the constant weight of worry about them is lifting away from me. I become aware of a shy feeling of relief.

As the months have passed, in stops and starts, we have made slow yet increasingly tangible progress. I find takers for my father's radio equipment and model planes. I'm glad they will be used and enjoyed, that the planes might once again fly. The old clothes, books and magazines are recycled, boxes of photographs taken away for safekeeping. It's still slow going. Every other object prompts a reverie. Emptying drawers and cupboards that have acquired almost half a century of sediment is a kind of archaeology. Some finds are unexpected, others are familiar, but each must be contemplated, their value and significance debated, their fate decided.

I take a plastic rubbish bag into my old bedroom to start clearing out the books and papers of mine that are still stored there. Wedged at the bottom of the holdall that I'd once used as a schoolbag, I find a drawing I did as a teenager. This crushed drawing might have been made on an evening when, much like every other, having walked the dog, I would unzip my schoolbag, pull out a dog-eared textbook and a fat ring binder that was splitting at the hinge, and sit down at my desk. I'd open the maths book, then take a pad of loose-leaf paper, pick up a pencil and carefully start to draw a horse. I drew picture after picture like this one, of girls like myself riding half-wild horses with tangled manes and strong, galloping legs. Or just horses, free and self-reliant. I seldom kept the drawings, nor did I show them to anyone. That was not the point. I did not draw to communicate or to gain praise or attention. I did not draw for others at all. I drew for myself. The A4 sheet was my playground, a big, white, open space I could move into and feel how wide it was, how anything was possible here. No matter how narrowly constrained the rest of my life might be, here I could move around freely in a world of my own shaping. Fold it away. Turn the page. Smooth out a new sheet of paper. Lift the pencil. Draw again. *To draw* is to pull something towards or behind you. *Drawn towards, to draw out*, this word, *drawing*, has longing and movement and love in it. *To withdraw*: it has privacy, and safety in it too, contemplative retreat. *Long drawn-out*: it has time in it, patience, endurance and tenacity.

As school exams approached, I used study as an excuse to avoid my mother as much as possible, spending more and

more time in my bedroom. She was usually still in bed when I left the house in the mornings, and when I came home again I would quickly retreat to my room. I remember one such afternoon when she came upstairs to look for me. I was sitting at my desk, drawing and daydreaming, Poppy dozing companionably on the floor by my feet. I heard my mother's smoker's cough at the top of the stairs, her feet shuffling across the wooden floor of the landing. She had probably been in her chair most of the day, alone in the house, watching the clock, smoking hard, waiting. The doorknob rattled as she took hold of it and turned it. Her long fingernails clattered lightly against the door as she pushed it open and peered round, breathing fast, her eyebrows lifted high on her forehead. Her face was pale, her eyes a cold fire of dread. Her hair and clothes were dirty. I felt sick to look at her. And sick with myself. I was a bad daughter, distant, hard and unloving. Quick to anger. I looked at her, staring fiercely, as if my gaze alone could shove her away from me.

'What?'

'Come downstairs?' she asked, tentative.

'I've got homework!'

I looked down at my desk and pulled the maths textbook over my drawing, pretending to read while the equations swam before my eyes. I heard the door close again, and her footsteps treading the stairs carefully as she went back down to her chair and turned up the volume on the television. I drew another horse. A young one, with fine, strong legs. I spent a long time getting the pattern of dappled grey markings across the haunches just right, losing myself in the details of how the light falls across the veins running under

the skin of the long, bony face. It took me a long time. When it was finished I looked at the drawing for a while, unwilling to leave its unfenced world of big skies and galloping horses just yet. But in the end, when I looked up, I was still in the same room and my mother was still asleep in front of the television downstairs. I folded the drawing away. No need to keep it. I'd draw a new one tomorrow. Soon it would be time for dinner. I would sit at the table with my parents and eat mince and potatoes with the television news on loud. Fifteen years old. So nearly grown. Waiting.

I smooth out the old, yellowing paper of the drawing, peering at this small window into the inner world of my teenage self. The drawing looks childish and stiff to me now, obsessively detailed but out of proportion, the horse's legs much too long. What I once thought of as a kind of freedom now looks like a spindly little thing stranded alone in the middle of an empty page. I am not that girl any more. I don't need to keep this drawing now, any more than I did when it was first made. It goes in the bin.

In the lounge, I see that one of my brothers has taken down all the pictures and stacked them neatly against the wall. Among them is a painting of my mother. As a teenage girl looking for a lost mother, sometimes I would go and search for her, even while she slept in her chair. I sought out clues hidden around the house. I would come upstairs and look at this painting, quietly, with the door closed. It's a self-portrait she told me she did at evening classes at Glasgow School of Art, when my brothers were little, before I was born, before our family ever came to this house. She didn't paint after that, as far as I know. There is another

self-portrait somewhere, made about the same time, this one a sculpted plaster head, painted gold and stuck on a metal spike. It stood on a windowsill for years, nodding at you in an unsettling way if you accidentally knocked into it. But this painting is actually a pretty decent piece of work, a good likeness, the brushwork loose and light, something lively in the yellow of her blouse, the touch of pink lipstick, though my mother once told me the tutor had helped her with the tricky bits around the nose and mouth. As a girl I would stare at the portrait for a long time and try to imagine who this woman was, what she might have been like.

Sometimes I would creep into my mother's bedroom and open her wardrobe, pull out the emerald green lace cocktail dress, the black mesh bolero with gold sequinned edging, the satin evening gloves and clutch bag, looking for the woman who had worn these beautiful things. I would look at photographs taken when she was very young and I could hardly believe how beautiful she was, arrestingly so, like a 1940s film star, with porcelain skin, gleaming dark curls and a radiant smile. In the painting my mother is a little older, in her mid-thirties perhaps. She has a sense of poise, seems aware of her own beauty. But she holds herself a little stiffly, almost guarded, looking slightly off to the side.

I would open the glass-fronted cupboard on the other side of the lounge that contained an impressive row of volumes, a full set of the *Encyclopaedia Britannica*, resplendent in gold-tooled faux-leather covers. Bought from a door-to-door salesman decades ago, the encyclopaedia lent the whole room a certain gravitas and fragranced the cupboard with its delicious book-ink smell. But it wasn't the

encyclopaedia I'd pull down in my search for clues to who my mother might have been. Instead, I reached for one of the two hardback anthologies of poetry that sat next to them. I didn't work out until many years later that these were 'vanity' publishing, impressively thick collections of mostly awful poetry, paid for by the authors, who received a few copies each in return. My mother had a few poems in each of them, published in 1971, when I was still a toddler. No one had ever mentioned the books to me. I don't remember when I first came across them and found my mother's name in them. I kept quiet about my discovery, as if it were a family secret I should not have uncovered. When I re-read the poems now, I see they are heavy-footed, verging on cliché, about rainbows and God and feeling left out at a party. But they touch me, and I have kept them. They offer a glimpse of her inner life, show me she had aspirations and intelligence, but little in the way of education beyond school.

I know so very little about her. The stories we tell about ourselves survive us, told again once we are gone, an afterlife of anecdotes. My father was full of colourful tales of his boyhood in Canada and Aberdeen, but my mother never told me much about herself. I struggle to think of a single story she told me about her girlhood, of her life before I was born. It is another way she is lost to me. Most of what I do know about her past came from my father. I know she grew up surrounded by many sisters in a big, close-knit family in a small village among the East Durham coalfields, where her father, his father, and his father before him had all worked down the pit. My mother left school to work at the local

miners' hostel during the war. There she met my father, who had been drafted to serve in the mines as a 'Bevin Boy' to feed the war effort's insatiable need for coal. My mother was seventeen and my father just turned eighteen when they met. They were together for the next sixty-eight years.

They married shortly after the war ended, and moved to Scotland, where my newly demobbed father had returned to finish his training with the BBC. My mother left her pithead village and her gregarious tribe of sisters for a new life in grimy post-war Glasgow. Photos of that time show them as a strikingly handsome, sharply dressed young couple. My mother became a typist, a typewriter sales rep, an office secretary, a wife and, after a few years, a mother. But she had, I think, always a sense that she was made of finer stuff. Before illness claimed her, she played the piano, listened to Beethoven, wrote poetry, went to night classes at the art school. I had glimpses of this. It was my mother who, for a birthday treat when I was small, had taken me to see Tchaikovsky's *Nutcracker* from the steeply raked top circle of the King's Theatre in Glasgow. I sat beside her up in the gods, dizzy with the height, the sweeping curve of the auditorium plush with red velvet and gilt, the expectant hubbub of the audience filling the stalls below, and was entranced by the swelling music of the orchestra and the glittering world on the stage. It was my mother who took me to the Kelvingrove Art Gallery and showed me her favourite painting, Dalí's kitschy but unsettling *Christ of St John of the Cross*. The crucified, yet bloodless and unwounded Christ hovers in the sky like a UFO over an evening shoreline. Night seems to be falling, yet the back of Christ's drooping

head and shoulders is side-lit by a light as harsh as an arc welder's spark. Somehow the viewer floats above it all, a disembodied eye. It's a hallucinatory scene that strikes me now as a curious favourite, but she always kept a postcard of it on the mantelpiece by her chair.

So it was my mother who played me classical music and who first took me to an art gallery. But it was also my mother who fought so hard to stop me going to art school that I had to threaten to cut off all contact with her if she didn't let the matter rest. I was just seventeen years old but, in those days of grants, becoming a student meant becoming financially independent, so it was not an empty threat. My father was about to retire, so I was eligible for the full grant and had every intention of using it to leave home. We both knew she could not stop me going. I had doubts at first, and hesitated over my decision. I didn't know much about art, just that I was good at drawing. I knew it wasn't a pragmatic choice. But the more I fought with my mother over it, the more certain I became.

Arriving at art school in Edinburgh, nervous and naive as I was, felt like a homecoming. I found a world I fitted into sweetly, and knew that I had found my place. I loved the freedom to ask my own questions, the open-endedness of creative work, the excitement of discovering new ideas. I loved the light-filled, paint-spattered studios overlooking the castle high on its rock, the equally paint-spattered, enviably cool final-year students, rolling cigarettes with charcoal-blackened fingers and drinking coffee in the student club. I loved the busy workshops full of tools and sawdust, plaster bins and welding gear, the paintings

propped nonchalantly in corridors, the life models shuffling between classes in slippers and dressing gowns, the Greek and Roman plaster casts watching over us all with blank-eyed grace. Whole days were spent drawing, painting, making, learning to use tools, to build things, to make ideas take shape and become real. I loved my new home town too; elegant, blustery, convivial Edinburgh, discovering a city of layers the casual visitor never finds, the rough edges far from the tourist trail, the noisy dockside pubs open till the wee small hours, the nightclubs in the maze of underground arches that threaded beneath the Old Town, dimly lit, fuggy spaces that smelled of beer, damp brick and cigarette smoke. I made new friends, discovered that, with my mother held at a safe distance, I could be happy. I began to grow into my own life, making my own decisions, paying my own bills, working long hours at college and in part-time jobs, stumbling home in the early hours from club, pub or party, building friendships that have sustained me ever since. One afternoon, early in my second year, I climbed the college steps carrying a box of heavy manila ropes I had scavenged from a warehouse down by the docks and thought I might use to make something, I wasn't sure what. As I pushed in through the doors heading back to my studio I gave a little skip of delight, autonomy coursing through my veins like an energising power.

Though I haven't used this old bedroom of mine for decades, over the years I have deposited various belongings for temporary storage and never got round to retrieving

them. There's more of my stuff here than I remembered. Drawing boards and picture frames are stacked by the door. Books I last read decades ago line the shelf above the desk where I used to draw and do my homework. From under the bed, I pull out a pile of drawings and paintings from those early art school days, thick with dust. I haven't looked at them in a long time. As I leaf through them I see how the long hours of drawing classes show their effects here in a new lightness of touch, an easier, more fluent accuracy of line that only comes with practice and soon gets rusty if neglected. I go through the heap, thinking I might hold on to one or two for old times' sake. I was not a sophisticated young artist, I see that now, although some drawings are sensitive and atmospheric. There's not much I'm tempted to keep.

There's one self-portrait here, in charcoal, all deep, moody blacks. I guess I'm about twenty-one in it. But it's not a picture of the optimism and energy I remember of that time. Its atmosphere is sombre and introspective. I have drawn myself leaning on my elbows over a table, gazing just off to one side, looking preoccupied and unhappy, as a fuzzy, dense disc of black, like a dark planet or a black hole, seems to slide in to fill the space above and behind my head. It reminds me that my youthful happiness was unsteady and needed careful tending, a choice I had to make again every day. There were also times when I would realise I had not quite left it all behind me, that my mother would always be part of me and part of my life, and that growing up in the shadow of her illness had left its mark on me. Maybe that's what I was thinking about when I drew that dark shape

looming overhead. Or maybe I was testing out the tired old cliché of the tortured artist, trying it for size.

But I knew enough, even then, not to buy into the romantic myth of the suffering artist who must teeter on the creative edge of sanity to produce his (and it's usually his) groundbreaking work. From where I stood, I could only see mental illness as destructive, a narrowing of possibility, siphoning energy away from creative work. If I was clear about anything back then, it was that I did not want to follow my mother down that path. Psychotic episodes, depression, neurotic thinking, obsessive compulsions did not seem very creative to me.

On the one hand we have this supposed link between mental illness and creativity, with study after study carried out looking for some connection, and yet on the other hand we are told that art is therapeutic, that it aids recovery from mental distress, that it promotes wellbeing and social inclusion, integrating the whole person. You can't have it both ways. Many studies seem to begin with the tacit assumption that people who work in creative professions are intrinsically more creative than teachers, plumbers, chemists, receptionists, car mechanics, as if they are somehow cut from a different cloth, when perhaps the more salient differences lie in the opportunities, education and financial support afforded their creative impulses. In any case, while most people could certainly rattle off a list of creative people with mental illness, this list is dwarfed by the uncountable numbers of creative writers, artists, musicians, playwrights, potters, choreographers, composers who have lived stable, productive lives. But these people don't make the news.

There's nothing like a dramatic life and an early death to assure one's place in the canon. Museums and art galleries cash in on the romantic myth of the tortured genius of suicides like van Gogh or Rothko, giving them blockbuster shows, their life stories told and retold. I have always found the persistence of this myth perplexing and frustrating.

Both creative work and mental illness may involve unusual ways of thinking, but creativity also means persisting through setbacks, making careful judgements, finishing the job, meeting the deadline, balancing the budget and getting the work to an audience. Being able to get out of bed and face the world every day is handy. Living a long and productive life helps too. But this is not the stuff of myth-making. The stream of studies and articles that try to prove a direct link between creativity and mental illness seem largely to ignore the more mundane factors that have been firmly linked to poor mental health: low pay and insecure livelihoods. These are not romantic, but grindingly stressful, and stress is bad for anyone's mental health. Surviving in the 'gig economy' is nothing new for artists. Apart from a few high-profile individuals, for the vast majority of artists making a living means having to come up with fresh ideas to high-pressure deadlines and achieve them on tight budgets and often low pay, in an industry that sees burnout as an occupational hazard, or even a badge of honour.

Nobody is creative when they are too unwell or too heavily medicated to function properly. Involuntary compulsions, obsessive thoughts, delusions, panic attacks, manic bursts of energy with no brakes and no criticality, and the heavy toll of suffering that comes with them, don't of themselves produce

great art. That so many artists have been, and continue to be, creatively productive despite such difficulties is testament to their sheer tenacity, their ability to hang on, haul themselves back, get back to work, not to their illness. Illness and pain narrow us down. Suffering shrinks us. Creative work opens us out. Neurosis is obsessively repetitive. Creativity is, as Bachelard said, dynamic, supple, open to change. Where pain fragments, creativity integrates. It makes connections, draws meaning and structure from the chaotic rush of life. Creative work is everything that neurosis and pain is not. It is expansive, a healthy, adaptive behaviour.

Even in times when the space I had for creative work was not a physical studio – I usually couldn't afford such a luxury outside a residency – but a desk in the corner of the sitting room, a laptop screen, a notebook, even just a sheet of paper, it has always been an inner space that has felt sustaining and balancing, an open place of serious play and complete presence. It's a kind of meditation, alert, interested, curious, calm. Drawing, making or writing, I can slow down and pay attention, see how things fit together, how they echo and repeat, align themselves into some kind of pattern. Creative work, with images or words, is an open space to enter, a way of thinking, reflecting, slowing down enough to make sense of the world and draw some coherent meaning from the giddy rush of experience. My mother's painting, her few poems, her dog-eared piano music, show me that this was a space she must have felt drawn to in some way too, before her illness. In that, it is something we share. Perhaps this open space of making art and writing is another kind of clearing or opening, a space between where

I might find some meaning in my mother's illness and suffering, and make whole something that was broken long ago.

I set aside just one or two old drawings to keep as mementoes. The rest I stuff into a bin bag, pile it with the other bags awaiting the next carload for recycling and head for the train back to Edinburgh. I get home to my flat just as the sun is setting and the streetlights flicking on. This half-light is the time between sunset and night, or between night and sunrise, when the sun is hidden by the horizon but its light is still visible. At both dusk and dawn, here in Scotland, twilight lasts a long time, especially in summer, as the sun slides along the horizon, rising and setting at a less acute angle than more southerly latitudes. In Gaelic culture, it is said that dusk is a 'thin' time, when the membrane between this world and the next is at its most permeable. We call it the gloaming. It is a time of day that is easily missed, often rushed though on the way home from work, run over in traffic, blustered away by the TV news or bleached out by the hypnotic glow of the smartphone screen. But, if I remember to meet it empty-handed and silent, it offers a translucently delicate hush.

I am not much of a morning person. Dawn twilight is raw and anxious, the day ahead tugs with obligations and deadlines. But I love this twilight of dusk. At this northern latitude night doesn't fall. It seeps. Colour drowses away to weightless greys. The light is slender, tentative, sinking. As I sit working quietly at my desk, I hear a car door slam outside with a heavy *chomp* and an engine starts up and pulls away as someone leaves one of the nearby offices. Silence rolls back into the space it leaves behind. There's a

sense of suspension that comes with dusk, the dimming turn inwards, an asking slowness, like a question left hanging. The surfaces of things seem to become more porous as the daylight fades. Without all the light clanging off them the books on my bookshelf, the row of sea-worn pebbles on the windowsill, the chairs, the doorknobs, the notebooks, the stack of student papers on my desk, the walls of my room, all seem to come loose, soften, ease off being themselves so emphatically, become less fixed and certain.

As the busy facts of the confident daylight world begin to fold themselves away one by one into the darkness, I can hear the blood singing in my ears and something tight falls away from me. Dusk is a loosening off, a falling away. It feels a little like sadness, but it isn't quite. Everything is so flat and winter-grey now that it might feel sad, but no, it's not sadness, nor even quite melancholy, but a feeling of pause, of things coming to a momentary standstill. Daylight is tight, briskly practical, get-on-with-it cheerful. It presses on the outside surface of things, pushes them together to become more thingly, more solid. At dusk everything comes a little undone. There's a sense of possibility.

I am expectant, but of what I don't yet know. I find myself motionless, caught willingly in a spell, suspended in this pause between day and night, simply waiting. Just this. Just waiting, sitting in the half-light, unblinking. Things sound differently at dusk. Every sound takes on the quality of a sigh: a car passing, a kid yelling in the street, the bark of a dog. A motorbike accelerates, turns the corner into a side street, its fat exhaust echoing off the high walls of the buildings as it goes. Orange streetlights come on, turning

everything else blue. A quick flare of yellow from passing car headlights crosses the window. Dark is unfurling itself now, as much as it is permitted in the city. Yellow-orange squares bloom like flowers as people come home from work, flip a switch and join the global self-blinding by industrial light, each lamp playing its own small part of that picture of the Earth from space at night, all webbed and jewelled with electric light, gorgeous and terrifying. To switch my own light on will instantly turn my windows into black mirrors, and the dark will seal them up and press against them. So I sit quietly as the light fades and I don't switch my houselights on just yet, but feel the slow-sliding tilt of evening. I let the day's business slip away with the fading light. The streetlight is shining into my room now through the branches of the birch tree outside. The wind is blowing and it sets the light dancing spectral on the wall in my dimming room. It seems like I can hear evening, like a low hum. I feel it tingling through me, luxuriant and homely.

I am still looking for her, the woman who was my mother. She is not in that house in Glasgow now, though I have been searching through it for so long. Perhaps she never was. Perhaps she is here, in the space of the unwritten page, in the dying light and the hushed pause. If my father can be found in thoughts of light, it is here, in the gathering dark, that I must look for my mother. Let evening bring me home to her. In this little flat, the home I have made for myself, where I feel safely held, I can let my anger and sorrow fall away. Let evening soften all my hard surfaces and certainties. Let night fall. Sometimes you just need to sit with the dark awhile. Let your eyes adjust. See what emerges.

DARK MATTER

A dark in things, in wild rose,
 a stalk, a line coming out of the mouth and
curving, is weight, privacy, sleep,
 a cache of fat
the seeable thing sucks on, turns to, and
 lives with.

<div align="right">Tim Lilburn</div>

After more slow months of sifting and rummaging, of long, dreary afternoons among the dust and dead moths, upturned chairs and bulging rubbish bags, at last we had retrieved all we could, and called a house clearance company to remove the big, heavy items like furniture and carpets. It took a full ten truckloads, but they took away all the worn-out sofas and chairs, the unwieldy wardrobes and sagging mattresses, the rusted cooker and fridge, the big Persian rugs my parents had bought second-hand in the 1960s when they were deeply unfashionable and could be picked up cheap at auction. The pile on them was so worn and eaten by moths that they looked like cinders over sackcloth. Now everything is gone in a sudden purge. The

clearance men finished the job in a single afternoon while we were all at work. It's a relief, to have it done, but I am glad I didn't need to be here to see so much of my parents' lives end up thrown unceremoniously into the back of a truck.

And now I have come back to the house for the first time since the clearance company have been and gone. More than two years since we began working our way through all that was left behind by our parents, the whole place has now been emptied, so suddenly bare it's disorientating. My feet echo on the floorboards in a new way now that the furniture and carpets have all gone. So has a certain charge that the air once held. I am a clumping, noisy intrusion into the house's empty stillness. I go down to my father's room. Everything of him is gone now. How small it looks, as if the space itself has been flattened out, just three quick steps across the bare floorboards from door to window. The dilapidated kitchen has been stripped out. The basement sitting room is bare boards.

Upstairs in the lounge is the very last piece of furniture waiting to be moved. My mother's piano still stands by the window in the corner of the room, exactly where it has stood for forty-five years. It is my piano now, my mother's legacy, the only object named in her will to be left specifically to me. I think she had decided it should be mine because at one time I had played it often, if badly. But I haven't played for years now and I have no space for it in my small flat, so it sits here while I try to figure out what to do with it. It's a baby grand, with a warm chestnut veneer and chipped ivory keys. It hasn't been tuned in years and isn't a fancy make.

So although it's undeniably a handsome piece of furniture, it's also a big, out-of-tune piano that nobody seems to want. But I can't just dump it. It's my mother's piano and she has left it to me. I am ungrateful, I know. Her gesture was well meant. But it feels more like a problem than a gift.

Three tufts of rotted carpet remain under the piano's feet where I had cut holes in it so the clearance men could take up the rug without shifting it. The piano stands alone, everything around it gone. Its elegance seems out of place now, like a bewildered antelope in a bare zoo enclosure. How much the arrival of this gracious instrument must have meant to my mother I can only guess. She must have felt she'd come a long way from her girlhood in that colliery village.

I was very young when my mother first became ill. I was too young to remember when it all began. Timelines are muddled. Chronologies make no sense. I don't remember the first 'breakdown' clearly. I don't remember when she was first taken into hospital. There was a night in the caravan at Aberfoyle, where we often spent weekends and school holidays, always keeping the same secluded pitch on the top of a hill, surrounded by bracken and gorse and with open views of the hills. We were all in bed in the dark and my mother was asking again and again, 'What time is it?' and my father not answering, my brother not answering, my father telling her to be quiet, and then a silence charged with fear or anger. My mother was talking as if she could see and hear things the rest of us couldn't. I think that might have been the first time. She kept on asking what the time was and talking about angels. Nobody answered. Finally I

pressed the little button on my LED watch, lighting up the inside of my sleeping bag with an eerie red glow, and I told her the time. I think it was something like 3 a.m., some witching hour of the night when I would normally be fast asleep. And she said I was an angel too and that I would go to heaven and I felt pleased, but also unsettled because something wasn't right and I didn't know what it was. I buried my nose in the fuggy warmth of my sleeping bag.

I don't remember that my father put cold towels over my mother's shoulders that sleepless night (or was it another?), trying to calm her down. I think my brother might have told me about that. There was a reddened cheek my mother hid with her hand, but I don't remember the slap. Maybe that was another time. I don't remember my father sending my brother to run through the dark campsite with a torch to call an ambulance from the phone box on the main road. My brother told me that story much later, reliving his own fear and alarm. Did they take her away then? Or another time? I don't remember when she left, or when she came back. I don't remember how many times she was in hospital, or for how long. I don't remember ever going to visit her in hospital. I don't think I ever did. I don't remember if I was asked.

I don't remember anyone ever talking to me about her illness or telling me what it was called. I don't remember anything ever being explained to me. What was happening to her was something that had no words, no names. It could not be spoken about. It could not be changed. It simply had to be lived through. I think I remember an uncomfortable meeting with both of my parents and someone who

might have been a doctor or a therapist of some kind. I felt squirmy inside and didn't want to be there. I think the man might have asked me something about how I was, and I didn't want to talk about it, not in front of my parents, not with a stranger. I didn't know who he was or why we were there. I didn't have words for what I felt or thought anyway. We never went back.

I think I remember coming home from school once, after my mother had been in hospital for a long time, to find she was back home, standing pale and uncertain in the sitting room. She looked different. Her clothes hung loose, like they were someone else's. Her face had changed, like she wasn't behind it any more. This new person seemed shy and anxious to please, like a polite visitor. We greeted each other awkwardly. I think I tried to be nice. At least I hope I did. But I wasn't pleased to see her. Her absence had felt like a reprieve, and now here she was, making me feel guilty about that.

I don't remember big chunks of those years. Vague shapes move in a fog. A few scenes leap out, starkly lit as if by a lightning flash, but I can't place them in time with any confidence. Sometimes I can map events onto verifiable facts such as what year I must have been in at school, what teacher I had. But a whole school year is completely missing from my memory, the year I would have been in primary three, when I would have been about six or seven years old. I remember primary two, with Miss Whitelaw with the shiny cheeks and pencilled eyebrows, and I remember primary four with Miss McFadzean, who wore her grey hair up in a bun and jumped every time we dropped a pencil on the floor. But

there is a gap between them I have no mental picture of, no matter how hard I try to remember. I don't remember who sat at the next desk, or who my teacher was. It's a year that has simply vanished.

But I think that missing year might have been when the recurring nightmare started. This dream came regularly for many years, still occasionally visiting long after I had left home. In it, I am walking through the school playground towards the main gate. But something isn't right. It's late at night. The playground is deserted. Everyone else has gone home. It's dark and raining, and I see that my mother is walking across the playground in her shiny red raincoat towards the infant school gates to collect me; she is hurrying and her face is white and terrified and she doesn't see me. I can't make her see me, and she walks straight past me. She is looking for me, but not seeing me, even though I am right there, and we have been going past each other all afternoon since school finished and now it is evening, now night-time, each of us still hurrying back and forth across the darkening playground in the rain, the wet asphalt glimmering in the streetlights, and she keeps on missing me, walking right past me, and I am safe but I can't make her understand this because she can't see or hear me. All she can see is her own fear, and I cannot reach her to take her fear away. I cannot make her see that I am here and I am safe, and my mother's lurching dread reaches deep inside my dream and tugs me awake with my heart beating wildly.

A flash of clarity, burnt into memory by the heat of a fury long passed. One sun-drenched summer afternoon, I returned from playing in the park with a friend. My sweater,

tied around my waist, had come undone somewhere on the way home. My playmate and I went back to look for it and dawdled home dreamily in the warm afternoon light. We said goodbye on the pavement outside my house, and I came downstairs to find my mother in her chair, pale and crying, two tall, uniformed policemen standing beside her. My sunlit afternoon was abruptly slapped away. The officers looked at me sternly as they folded their notebooks and left us alone. My mother's fearful anger ran headlong past my own as I stood before her, small and trembling, her white face a baleful moon above me. Her delirium of fear was a prison to both of us and I raged at it uselessly. She was a wall.

Young as I was, I knew one thing with fierce certainty: I was not going to go down with her into that place of endless fearfulness. But a little girl cannot please herself. Though she may try, the rules are made by grown-ups who say they know what is best for you. So I learned to appear compliant when necessary, and to hide, right in front of her, right there doing my homework at the table, drawing pictures in my room, watching television on the sofa. I could not get away from her control, but I would keep my distance. She would not know me. I would not let her know me. I told her nothing, asked her nothing. I kept my own fear sealed up tight. I beat my drum of anger silently, would beat on it for years to come, a battle drum for the days I did not feel brave. I did not want to be like her. I threw away my dolls and my skirts, and longed to be like the boys who ran in the lanes shouting and climbing, fearless and free.

Another moment, a few years later: I should have been

at school, but instead I was sitting on a plastic chair in the doctor's waiting room, schoolbag at my feet. Without explanation, my father had ordered me to get into the back of the car first thing that morning, instead of going to school. My mother was already in the passenger seat. By the time we got out at the doctor's surgery, I knew something was very wrong. My mother had been quite stable for a while and life had returned to a kind of normal, though we handled her carefully, like a grenade with the pin half pulled. But something must have happened during the night, because now she was pacing the waiting room, white-faced, talking to voices only she could hear. My father was hissing at her, 'Sit down! Come here and sit down!' but it seemed as if she couldn't hear him, only the voices, threatening. The other people in the waiting room looked away, their faces set with studied blankness. Don't look at the crazy woman. Don't make eye contact. I pretended I had nothing to do with her either, and sat as far away as I could, looking at the floor, my fingers gripping the chair, with a kind of dizzy fear like vertigo. I remember a hollow feeling, as if a blow had knocked the breath out of me, and worrying about being late for school, and about what excuse I could give to my ferocious teacher, who I feared would haul me up in front of the class demanding to know the reasons for my lateness, reasons I would never tell. When my father escorted my mother into the doctor's consulting room, I waited alone. Nobody spoke to me. I have forgotten what came after.

And this, from around the same time perhaps: I came home from school to find my mother sitting on the floor in

front of her chair. She did not seem to notice I was there. She had a notebook open beside her on the carpet and was absorbed in writing things down in it. Within the wall above the fireplace there seemed to reside some huge and prophetic knowledge, something holy and dreadful. She looked at the wall and asked it, 'Is he hiding drugs inside his guitar?' She placed the flat of one hand on her belly and with the other held the silver cross she always wore around her neck. The muscles of her belly twitched strongly, irregularly, as if in response to her question. She seemed to be able to decode this, carefully wrote the answer down in her note-book, and asked another question. I don't remember any of her other questions, except that they had the same tone of dark suspicion and that the answers arrived with the same complete and unassailable certainty. I went upstairs to my bedroom and closed the door.

A few years later: I was dressed and ready, nervous but prepared, to go and sit my final school exam, my strongest subject, English. It would last all day, with several papers to sit, one after the other. It was the culmination of so much of my education, with so much riding on the outcome, that I had been aware of carrying myself carefully lately. A broken wrist or a stomach bug right then would have been a catastrophe. My father had been away for work over the last few days and I'd had to prepare the evening meals, as my mother was not able. I was certainly no cook and the chip pan full of boiling oil terrified me, but I pretended to myself I was calm and pushed my fretting mother out of the kitchen. I was still pretending now, feeling shaky as I straightened my school tie and picked up my keys and bag.

But I was also determined. I could do this. I could do this well. And then I could leave home.

As I got to the front door my mother intercepted me. Still in her nightdress, she was pale and shaking, crying and begging me 'Oh! Please! Please don't go! Please!' She was terrified, convinced that something awful but unspecified was going to befall me if I went out, a kidnapping or a murder, she didn't seem sure what. She grabbed hold of my arm, tried to block my way. I hadn't told her how important today was for me. I had learned long ago not to tell her anything important about my life. But somehow she knew anyway. I never hated my mother more than I did in that moment. It felt like a deliberate act of sabotage. I pushed past her quickly, pulled the door shut in her face, double-locked it behind me so she couldn't get out, and ran as fast as I could up the street to school. I was still shaking when the exam paper was placed on the desk in front of me. But anger made me focused. My mind was clear and sharp. I wrote and wrote with unbroken concentration. When the exam was finished and I made to leave for home, I caught sight of my mother pacing anxiously up and down just outside the school gates. I quickly doubled back inside the building before she saw me, left by a side gate and took a roundabout route home to avoid her. When the results came in a few weeks later and I learned that I had aced that exam, I felt the grim satisfaction of a battle won.

And between these moments, forgotten, uneventful, regular days, piling up into months, into years, the stuffing of everydayness filling the space between those lurid flashes of memory. For long periods we were like any ordinary

family. My mother went to work. My father went to work. I went to school. We came home every evening. Meals were put on the table, homework done, the dog walked, television watched, schoolfriends came round to visit, holidays in the caravan were taken every August. A normal life, more or less. My brothers, adults now, came and went, trailing the glamorous scent of autonomy. I knew they had formed a friendship beyond home and often spent Friday nights together in the pub, but such freedom was as yet something I could only dream of.

Sometimes my mother tried to reach out to me. Maybe, even through the blur of her illness and medication, she could see how lonely I was. Sometimes we would spend an evening listening to records together in the lounge and she would ask me about school, show interest in my drawings, praising them. Somewhere, very faint and far off, is a memory of my mother playing the piano, always the same few pieces, Beethoven's 'Pathétique' or 'Moonlight' sonatas, a little bit of Mozart, her long nails clicking on the keys, her face tender and serious. It was a long time ago. I think I must have loved her then, because when I hear that same music played now everything goes still and tears I can't explain prick at my eyes. The space of those forgotten days isn't empty. It is full of energy and charge.

The top of my mother's piano is covered in the dust thrown up by the great commotion of removing everything around it. I open the lid of the keyboard. The keys are grubby, a bit sticky to touch. I press middle C gently. The note sounds

out clear and pure, ringing out in the empty room. Its sound fills up the stillness of the house in a way that makes me feel exposed, like voicing an awkward emotion out loud. I try a bar or two of an easy piece I once knew by heart but soon get lost. I play along the white keys, walking the whole keyboard from top to bottom and back again, just to hear the notes of this piano sing out once more. It's like hearing a familiar voice from the past, instantly recognisable; the off-tune bass notes, the singing tone of the mid-register, warm and romantic, that buzzy D below middle C, and the hard, glockenspiel tapping of the top notes, never very tuneful and now wildly off-key.

At one time this piano was one of my escape places. I'd come in here to get away from the blaring television, my parents in their chairs, their silences wrapped around them, dug in for the long haul. I would come in here and close the door and sit plunking my way laboriously through pieces, sounding one note at a time, reciting 'F-A-C-E, Every Good Boy Deserves Fun, Good Boys Deserve Fun Always.' Right hand, left hand, both together, counting out the timings, wondering to myself, What do good girls deserve? It would take me weeks, months even, but eventually I could gingerly navigate the first page or two of a few pieces, always stalling as soon as I came to a tricky bit. The big juicy chords in Beethoven were what I loved best. I played them slow as a dirge with lots of pedal. Lessons would have helped but I didn't really want to play in front of anyone. It was never about performing. It felt like something very private.

Sometimes I would lean my forehead on top of the piano, close my eyes and play one chord again and again, as softly

as possible, holding the sustain pedal down so I could untangle the sound of each note, hear how the harmonics changed as the notes faded out one by one, vibrating against each other then falling into sync. Or I'd play a scale very slowly, listening to the way each note was changed by the next one coming in, how some notes seemed to tilt towards each other with a tiny vibration that felt off balance, even sad, and some sat together cleanly, sounding cheerful and brave. The space between the notes seemed as much the music as the notes themselves.

Other times I'd pull out some of my mother's old sheet music and try to play the pieces I could just remember her playing, a long time ago. I was never quite sure whether playing them made me feel closer to her or further away. The piano seems to stand for all that my mother might have been, for the young woman she had been, once, before I knew her. Before everything changed. Maybe that's why she has given it to me, to remind me of who she once was, to share something with me that had once been precious to her, some far-off music from her life before, sounding out from the dark space of a long-forgotten evening. I try to bring back some feeling of connection to her, some memory of togetherness and tenderness between mother and daughter. But it doesn't come.

You just have to sit with the dark to learn its lessons, take your time, let your eyes adjust. In the end, what darkness shows us is that our eyes are not to be relied on, even though we believe so confidently in them. During the Enlightenment, scientists used the properties of light and lenses to see further outwards and inwards than ever before,

slowly opening up the worlds of the very small and the very big with increasingly powerful telescopes and microscopes. Galileo, Kepler, Copernicus, van Leeuwenhoek, Hooke, with their finely ground lenses, pressing forward their project to shed the clear light of reason on every dark corner of nature. More and more worlds in heaven and earth were illuminated. Mountains on the moon and hairs on the leg of a flea. Animalcules wriggling in a drop of pond water. But the picture that emerged was strangely disconcerting, dislodging certainty rather than cementing it. Looking for answers seemed only to lead to more questions. The image we once held of ourselves as the fulcrum around which everything revolved was steadily eroded. Copernicus discovered that the Earth is not the centre; it spins around the sun. Huygens suggested in the seventeenth century that the sun might be a star. In the early nineteenth century, from the measurements of Bessel and other astronomers, we understood that our sun is just another one of billions of similar stars, a main-sequence dwarf star of moderate temperature, and that our whole teeming world is just one tiny speck among billions of others.

In this steady displacement of certainty and control, we learned that the universe is wilder and darker than we ever imagined. We discovered that the illumination of light can only show us a fraction of what is. James Clerk Maxwell looked through the lens of mathematics and saw much further. He saw that light, magnetism and electricity are of the same order. He understood that light is not a thing, nor even a stream of things, but a humming radiance, of the same nature as the light we can't see, the whole wide spectrum

of electromagnetic radiation. We can only see the thin slice our eyes can focus on, and miss all the rest, unless we have an antenna like one of my father's to pick it up and turn it into something our senses can detect.

Only about 10 per cent of the atoms in the universe are bundled into luminous stars. The rest are scattered in the dark spaces between stars, as gas clouds, planets or dust particles, none of which give off light. Most of the theoretically visible matter in the universe is not incandescent like a star, but tucked away in the dark. The shining universe, the matter that we can see when we look up on a clear night, is a bedazzlement. Like the sun, it blinds us.

Not only is most of the ordinary matter in the universe hidden in the unlit spaces between the stars; all of the matter that we could ever see is, according to modern physics, just a tiny percentage of the matter in the universe. The rest remains stubbornly elusive. An astronomer called Fritz Zwicky first guessed at the existence of an invisible 'dark matter' between the stars in the 1930s, but it was Vera Rubin who proved it. In 1965, Rubin was the first woman to be allowed to make observations at the Palomar Observatory in California. When she faced objections that there were no 'facilities' for women, she cut out a little paper skirt, stuck it over a gents' toilet sign, said 'Look, now you have a ladies' room,' and got on with her work.

While raising four children and blazing a trail for women in science, Rubin carried out research that changed the way we understand the space between the stars for ever. When she measured the orbital speed of stars in Andromeda, a rotating galaxy, Rubin noticed that the stars on the edge of

the galaxy were spinning as fast as those at the centre. This was not what she had expected to see, because if the only mass in a galaxy were that of the visible stars, the ones at the edge would orbit more slowly, just like the distant planets in the solar system do. These fast-whirling stars at the sparse edge of the galaxy should be flung off out into space. There shouldn't be enough gravity to hold them in place. But somehow there is enough gravitational pull to hold the galaxy together. Working in the thick of family life with her papers spread across the dining table, Rubin pondered her puzzling data. She realised that, to account for all this extra gravity, there must be lots of invisible matter in those spaces between the stars, matter that did not give off light, but had a lot of mass. Her insight was controversial at first, but by 1980 it was widely accepted that she was right. It seems that the luminous stars in a galaxy occupy only the inner regions of an enormous sphere of unseen dark matter that makes up most of a galaxy's mass. It turns out that dark matter makes up 80 per cent of the mass density of the universe.

Astronomers still don't know exactly what dark matter is, but they know it's important. It's called 'dark' because it doesn't emit or reflect light, but really it's more transparent than dark. It doesn't interact with light at all, or with the electromagnetic force that makes normal matter seem solid when it is really mostly empty space, so it passes straight through undetected. Dark matter particles are streaming through us all the time, but they can't be seen or felt. They can only be inferred from the clues they leave behind in the large-scale structure of the universe, in the speed of rotating galaxies and the gravitational pull they create.

We may only just have realised it's there, but dark matter is ancient. It existed before ordinary matter. The incandescent constellations we see when we look up at the night sky only exist because the gravity of dark matter slowly pulled galaxies together and ignited the stars. Bright spiral galaxies like Andromeda are wrapped and held in a much vaster, invisible halo of ancient dark matter, its dull pull clumping galaxies together like dust seeding rainclouds. Dark matter doesn't emit or reflect light itself, and yet, by pulling matter together to create stars, it makes light possible. Here it is again, the space between things, not a blank void but, like the ether, conceived as the source of substance, energy and motion, the boundless *to apeiron* of the Greeks, fertile with possibility, setting matter ablaze as stars, generating light and life.

Since the Big Bang, the universe has been expanding. Astrophysicists assumed that this expansion would gradually be slowing down due to the gravitational pull of mass, including the mass of dark matter. But it turns out that the expansion of the universe is not getting slower. It's speeding up, as if something is pushing it apart. At a loss as to what this something might be, physicists have called it 'dark energy'. Very little is known about this dark energy, but as the universe continues to expand, the more 'empty' space there is, and so the more dark energy there is to push everything apart, which means the universe will keep on expanding faster, in a cosmic feedback loop making yet more space and more dark energy. Dark energy drives the acceleration of the expanding universe, and will keep increasing as the universe keeps expanding. Eventually the

universe will have expanded so much that all the other stars and galaxies will disappear from each other's view and darkness will reign again.

Thus it turns out that all the stars, moons and planets in a hundred billion swirling galaxies are nothing but a sparkle of bright froth on the surface of an unseen sea of dark matter and dark energy. As the streetlights of human knowledge are pushed further and further out into the night of unknowing, perversely what is emerging is not more certainty but more uncertainty. The bright light of human reason has shown us that most of the universe is dark, not simply because we have yet to shed light on it, but dark in its very nature. It seems to be that the true nature of the material world is not very material at all. It's not the things but the space between them that seems to hold all the answers. I can't pretend to understand the physics, but something about dark matter fascinates me as deeply as the ether does. Like the subtle ether, it is a metaphor that knows something before I do, that to find and properly grieve my mother it's not the brightly lit memories I should be looking at, but the long, dark gaps between them.

There's not much for me to do at the house until I can find a home for my mother's piano, so one weekend I take a trip to see a work by the artist Katie Paterson in an art gallery set in parkland just outside Edinburgh. I have known about Paterson's work for a while and always enjoyed the way her symbolic objects and poetic acts, often the result of collaboration with scientists, try to bring the distances of space and

deep time into the everyday world, frequently leavened with dry humour. I have seen a large wall map she made a few years ago, *All the Dead Stars*, each one of the twenty-seven thousand that have been recorded by astronomers so far, rendered as a tiny pinprick of light, and another project, *A History of Darkness*, an ongoing archive of thousands of slide images of the dark spaces between stars, each with its distance from the Earth noted in light years. It's a futile attempt to capture the infinite; each slide is plain black. There is nothing to see. Only darkness. The knowing bathos in Paterson's work shows how our longing for understanding always falls short, can only ever fall short, but that the attempt is still necessary. In her characteristic mix of deadpan and wonder, Paterson's attempts to fold cosmic scales into the everyday world seem to convey some sense of the incommunicably vast scales of space and time that astrophysicists must work with every day.

This piece, *Earth-Moon-Earth*, is one I have wanted to see since I first heard about it, simply because it seemed, by sheer coincidence, to bring both my parents' stories together. Paterson took the musical score of Beethoven's 'Moonlight' sonata, a piece my mother once played, and had its notes transposed into Morse, a code my father learned and used. She asked radio amateurs to transmit the radio signal to the moon and pick up the signal as it bounced back. She then had the returned Morse code translated back into music. In the final installation, the resulting music is performed by a 'self-playing' grand piano. I love the idea of this moon-bounced moonlight music so much that I feel excited as I walk into the gallery and catch sight of

an elegant gleaming black concert grand piano in the otherwise empty white space, its highly polished lid opened to reveal its golden, resonant interior, and I hear the first bars of that long-familiar music. What I didn't expect was the Victorian parlour séance spookiness of it. The piano keys move without a visible player. No piano stool is pulled up to the keyboard. I recognise the music immediately, but it breaks up randomly, a hiccup here and there, an arpeggio pushed off-centre by starting or ending on the wrong note. These gaps are where the radio signal failed to return from the moon, bouncing off a crater and careening into outer space instead of back to the receiving antenna. The music is so familiar that I hear an echo in my head of the notes that should be sounding in the silent gaps where the music has got lost on its way back from the moon.

There's something physical about the feeling of distance and absence here, the missing pianist, the hands that should be moving over the keyboard where instead there is only the soft thunk of the mechanical keys, the physical distance of the journey the music has been on, all the way to the moon and back, the expected notes that fail to sound, and the little lurch this causes as I lean in to hear nothing where a note should be. It makes me miss both my parents at once, and I want to linger a while, let the feelings rising in me become clearer, listen out for them in those lurching gaps. But the gallery is busy and noisy with families on this fine Sunday afternoon. I can't hold on to my thoughts in all the commotion, so I take them home with me, leaving the sonata limping on.

The dark part of the whole moon is how we know the

bright crescent. The lack shapes the present. We can never know anything entirely. But perhaps the answer is in the attempt, in the reaching, in the craning towards, in the trying and failing and trying again, until at last we recognise that it is the question that is necessary, not the answer. The dark moon is part of how we see the shining crescent moon. We lean into the lack. It feels like a gap, but really it's a connection. The parts of our lives we can remember and tell are so slight, just bits of flotsam drifting on the surface of a deep river of forgetfulness. My brothers, both older than me, will remember more: when the psychotic episodes began, how often and for how long my mother was hospitalised, what she was like before the medication flattened her, what her official diagnosis was, what passed for psychiatric treatment in the 1970s. But I don't want to ask them to fill in the gaps in my incomplete and confused memory, because this would be to replace my mother with theirs. These memory-less gaps are my dark matter, my centre of gravity, the missing notes I lean in to hear, the spaces in the web in which remembered episodes hang, brightly lit, suspended in time.

The numbness of forgetting leaves odd pains that come like twinges in a phantom limb. The body remembers. At odd moments, the nervous system spikes. At work that week, a big university meeting convenes; a boardroom with a wide table, senior managers with orderly piles of papers in front of them, professors tapping rapidly at laptops with an air of importance and concentration, agenda items listed, paperwork to be audited, statistics to be discussed, SMART targets to be answered to, new ones set. How on earth did I

get here? I don't remember choosing this. I stare blankly at bullet points of corporate jargon and acronyms, and feel a wave of fear rise, a dark energy coming from some hidden or forgotten place to push my professional sheen apart. I feel my face getting hot, a roar pulsing in my ears, my palms slick with sweat. As I wait for the meeting to begin, I slowly and deliberately look around the room, from left to right. I examine each windowpane, coffee cup, blind cord, light switch, door handle. I lift my glass of water to my mouth, holding it firmly in both hands so they don't shake visibly, and take one careful sip, fastening my attention on the feeling of the cold water on my lips, in my mouth and down my throat. I scan each face around the table, one by one, each holding all the unknowable mystery of another human being, with all their own fears and losses. Like a surfer caught out in a swell too big to ride, I let this wave of fear roll right under me as it lifts me up and sets me down again, no more real than a bad dream. By the time the meeting starts it has passed on through, and I am calm and competent.

The dark matter of all the unremembered hours, days, years, sinks away from memory, yet lends the present its gravity and momentum. The hinterland of my parents' long marriage, the sixty-eight years they spent together, is a hidden continent behind the tiny slice of their lives that I saw directly. I can only detect the rest, like dark matter, by means of its effects, in the silence gathered around a grief that lasted decades, a gravitational pull that held us all in place. In those last weeks they spent together, when I think my father knew he was dying, I saw a deep sadness

in him, but also a waning of his anger and frustration, small moments of gentleness towards my mother that I had not seen before, a hand resting on her shoulder for just a moment, a ruminative look across to her sleeping form when he didn't think I'd notice, which had a softness to it. What did I know of what had passed between these two people?

Under every forest lies a network of fungal filaments so fine we would not see it with the naked eye, yet it forms a vast, distributed organism without which the trees cannot thrive. Unfolding, year on year, into the darkness that is the space inside another human heart is a pale mycelial mesh that connects us, the delicate and complicated truth of love's persistence. Intimacy is not all in the bright daylight of communication and sharing, all the sunshine of that. It is also in this loamy dark. I think of my elderly father and I, on one of my Sunday-afternoon visits, sitting side by side watching television. I think of my mother, silent in her chair, curled in on herself, unseen, unheard. Shared roots of unspoken sorrow and love lie buried deep and bind us. The tea has been drunk and my father and I have covered the usual topics. There is only the long dimming afternoon, the three of us quiet, my mother now asleep, and my father dozing off in front of a John Wayne western. This is their legacy to me, this hushed and tender gloaming, love's dark matter, slowly pulling light out of darkness.

SWEET VITRIOL

Chlorpromazine is used to treat the symptoms
of schizophrenia and other psychotic disorders.
Common side effects of chlorpromazine are:
drowsiness, blank facial expression, shuffling gait,
agitation and anxiety, unusual or uncontrollable
movements of the limbs, a feeling of restlessness
and inability to sit still, abnormal movements of face
and tongue, slowed reactions.
Temazepam is a hypnotic benzodiazepine used
to treat insomnia and anxiety. Common side
effects include: somnolence, dizziness, fatigue,
problems with co-ordination and balance, lethargy,
impairment of memory and learning, slurred speech,
numbed emotions, reduced alertness, blurred vision,
inattention.

Adapted from *Encyclopaedia Britannica*
and *Mosby's Medical Dictionary*

After months of enquiries I have finally found a new home for my mother's piano, so I have come back to the empty house to meet the specialist movers who will be

taking it away. A thick layer of dust from the re-plastering of the basement sitting room is still settling on everything. I close the lounge door behind me and clean off the top of the piano, wipe the ivory keys and polish up the chestnut veneer. I want it to look respectable when it arrives in its new home. The piano stool is gone, so I stand, stooping slightly, and place my hands on the keyboard one last time, hands that look so much like my mother's it startles me. I stroke the keys gently, not enough to make a sound, looking absently out of the tall window onto the quiet street. I wait for some feeling to come, some great rushing ambush of grief or some tender understanding of the woman who once loved and played this piano and left it to me in her will. But nothing comes. No epiphany. No gusts of weeping. Just a wadded-up, dim sadness. I catch myself looking off to the side, head tilted, as you do when trying to see a very faint star.

Here come the piano movers now, piling out of a big white van. I count five, six men coming up the path, good-natured Glaswegians, bantering cheerfully, brisk and efficient as they work. Their movements are practised and confident as they quickly upend, wrap and strap the piano, lift its heavy weight onto the trolley, wheel it down the narrow hallway and through the front door. They pause to negotiate with each other – 'Okay? One, two, three!' – to smoothly lift it down the steps and lay it gently back down on the trolley. I stand uncertainly in the doorway, not sure what to do with myself, watching them wheel the piano down the path. Taken out of the room it has occupied for so many years and tipped on end it looks vulnerable, like

something just fledged. I have handed it over to the care of others, but they seem to know what they are doing.

I watch the men wheel the piano down the street to their waiting van. My mother left it to me and I am giving it away. I am sorry to see it go, but I have no place in my life for this gift, her legacy to me. As I watch it go I wait, as if listening for a faint sound, expecting something, anything, to open up in place of the numbness. It feels like asking a question, listening out for a reply but hearing nothing. No answer comes. Just a very ordinary and quiet sadness. The last of her is gone now and I feel so calm that it puzzles me. The sight of the piano being bundled away makes me realise it is three years now, almost exactly to the day, since I stood in this doorway and watched the ambulance drivers wheel my mother away, wrapped in a blanket and bound with orange straps, looking back at me with wide and fearful eyes that said I had betrayed her. She never came home again.

My father had been taken into hospital the day before. He had been on treatment for an enlarged prostate for several years, but the pain in his legs that had started a few months earlier was something new. I feared what it might mean. Something growing in his bones, pressing on the nerves. But he resisted going to the doctor. My mother seemed to be somewhere very far away now. She had folded the map of herself away long ago and we had long since lost the way to find each other. She would sleep almost continuously, give me one-word answers. She became more immobile, more remote, more silent, though she still oscillated between wild anxiety and groggy sedation. My father told me she had spent an entire afternoon picking up the phone by her

chair, dialling, listening, breathing heavily and hanging up, again and again. When he asked her who she was calling she didn't answer. But when the bill arrived he saw that she had run up hundreds of pounds calling his mobile phone again and again, hanging up just as it connected to his voicemail. 'The phone was switched off. I was sat right next to her,' he told me, angry and perplexed.

The house continued to disintegrate around them. Lights dimmed when the kettle was switched on. Switches and sockets buzzed and crackled alarmingly. Damp crept up the walls, plaster swelled and bowed, black mildew spread across the wallpaper. Taps dripped. I came at weekends, fixed what I could, tried and failed to keep up with the privet hedge and the front lawn. I scraped the smelly, disintegrating cork tiles off the bathroom floor and replaced them, and uselessly polished the soot-blackened copper canopy over the gas fire until it gleamed like a 70s pub interior. I hoped that after I had gone home my father would see in its renewed sheen that I loved him and was trying to help. That hard, cold winter, which would turn out to be their last one together, I walked towards the house along the slippery, ice-packed street and saw their windows were fogged with feathers of ice on the inside of the glass. It was a bitter –15°C outside and my parents were both sleeping in unheated bedrooms. I brought them extra heaters, woollen blankets, hot-water bottles. But I felt useless.

It was a relief when that winter passed, but as spring turned to summer, my father became yet more unsteady on his feet. His voice sounded exhausted on the phone. I quietly cancelled my holiday, made my visits more frequent,

tried my best to help. When I'd call ahead to ask him what he needed me to bring from the shops he would say 'paracetamol'. He could only buy one small pack at a time at the supermarket. I would bring bags of groceries when I visited, to save him an exhausting trip to the shops, but he had no appetite and was struggling to eat anything. I'd buy sachets of baby food that he could suck at, and he seemed to manage a little of these. I bought so many, every flavour I could find, as if they could make him better. They gathered in piles on the table by his chair, mostly untouched. He seemed to have sagged away a little more each time I saw him, as if he was collapsing from the inside. His eyes were unfathomably sad. Each time I visited them during those last months, after I said goodbye and left the house, I would weep quietly all the way up the street.

In September the new academic year began, and another wave of new students broke over me. As I plunged around my world of commutes and meetings, students and colleagues, lectures and tutorials, emails and phone calls, all the bright nonsense we plough through in the thick of midlife, I would suddenly think of the two of them sitting silent together through the long afternoons, my heart turning towards them in a lull perhaps, in a dull meeting, and I would give anything to be able to take my father's pain away, to bring my mother back from her faraway place, to move them from that cold, dirty house and give them somewhere warm and clean and safe to live. But I could not make this better. I did not know how. I had never known how.

I moved through those last weeks of my parents' life

together in the old house feeling like we were all about to fall off a cliff. My brothers visited when they could, after work. But it never seemed enough. When I came I'd sit in the chair next to my father and try to make cheerful small talk. My mother barely spoke. My father would look at his watch and pull out the pack of paracetamol and check the mark he had scored on the pack with a pen, like a prisoner scoring off the days, so he would know how many he had taken, and when it was safe to take more, watching the clock, willing the hands to go forward so he could take another two tablets. He gently brushed me off whenever I suggested that he needed to see a doctor, at least to get a prescription for some stronger painkillers. I couldn't persuade him to make the call. I think we both knew that call would set unstoppable things in motion. It would be the call that pulled the plug on everything.

Finally, when I couldn't stand to watch them unravelling any more and my daughterly concern was having no effect, I asked my brother to speak to our father, hoping he'd be more willing to listen if it came man to man. It worked. My brother managed to persuade him that he needed medical attention, at least to get his pain under better control. From there, events moved swiftly, and that same day the ambulance came to take him into hospital. I took the next day off work and drove through from Edinburgh first thing in the morning. My mother hadn't been left alone in the house for years, and although my brother had tucked her into bed the night before, I was worried what I would find when I walked in. When I opened her bedroom door she was sitting on the edge of the bed in her nightdress, holding the phone to her

ear, breathing heavily, not speaking, listening to the dialling tone as if she found the sound soothing, her bare legs and feet exposed and cold. When I asked who she was calling she looked confused, as if the question had not occurred to her. 'No one!' she said, holding the phone tightly.

I washed and dressed and fed her breakfast, lifted her into the wheelchair, wheeled her through to the lounge, helped her into an armchair and waited for the doctor to arrive. Home visits were unusual but the doctor needed to make a formal assessment and request hospital admission while arrangements could be made for her long-term care. I listened as he spoke patiently with my mother, slowly and clearly, making sure she understood, accustomed to pacing himself to match the very elderly. He asked her if she could stand up. She looked at him with her eyes bright and watchful, wary. 'Yes!' she replied. But she couldn't get to her feet, even leaning heavily on her walking frame. 'I don't want to go to hospital!' she told him. Her eyes flicked to me. But there was no alternative, with my father now admitted. She needed twenty-four-hour care. I knew what my mother's glance had meant, but I couldn't, wouldn't, give up my job, my income and my own home to come and care for her here.

I sat beside her as the doctor made a call to the hospital. I overheard him explain that my father had been admitted the previous day with 'extensive bony metastases'. My mother was listening very carefully. I wondered if she understood what that meant, that my father wouldn't be coming home again, unless it was to die here. She gave no clue. It confirmed what I had suspected for months, that my father's enlarged prostate had changed into something

more aggressive, that he had sat through months of crippling pain, self-treating bone cancer with sixteen-pill blister packs of paracetamol from the supermarket.

After the doctor left I waited with my mother. Neither of us spoke. After an hour or so the ambulance crew arrived, bringing a clatter of activity into the congealed stillness of the house. Kind and competent and confident, they bundled her up like a newborn in a white waffle blanket and lifted her onto the gurney, strapped her in securely, wheeled her down the narrow hallway, lifted her with a practised 'one-two-three' down the steps and pushed her along the path onto the street where the ambulance waited. I hesitated in the doorway, checking my pockets for keys, purse, phone, holding a bag with some toiletries and things my mother would need in hospital. My mother looked back at me from the trolley, wide-eyed and blinking in the sudden daylight, like a stunned chick pushed unwillingly from the dark funk of the nest. I pulled the front door shut behind me, with a sense of something enormous ending, and climbed into the back of the ambulance. After the years of slow decline it had all ended so swiftly. That was the last time the house was occupied. My father was dead within days. My mother stayed in hospital for three months before going into a nursing home. She died just over a year later.

The men load the piano, close the doors of the white van and pull away down the street. I watch them drive away with the last of my mother's belongings, in a strange re-run of her own departure, puzzled at my own lingering

numbness. I did not cry when my mother died. After her death I felt at first blank, and then angry, as if I had been cheated out of something rightfully mine. For weeks I dreamt each night of punching her in the face, hard, with my fist clenched, in a cold, relentless fury. I dreamt of heavy winter coats piled over me, smelling of old wool and mouse droppings, of hiding in dark cupboards and pulling the doors closed to shut out the light, of crouching under tables, weeping on and on as puzzled, kindly men who love me looked on, not knowing how to help me. I woke exhausted, shocked at the rage and self-pity my dreams revealed.

The last room of the house has now been emptied, and into the space left behind rolls nothing but blankness. This is not the luminiferous ether that carries voices in the form of light, nor the airy escape of voluptuous flight. It is not the creative mystery of dark matter, nor is it the expansive force of dark energy. This ether is the darkness of my mother's long years of somnolence, of the little brown pill bottles always at her side, the repeat prescriptions ordered by phone, the same drugs taken daily for decades, her hiding place in sleep, the effects of her medication heaped over with side effects heaped over symptoms of her illness until she was buried alive. It is the forgetting of a whole vanished year of my childhood, the distance I kept, the angry numbness that never quite left me, my blankness now she is gone. It is the atrophied stump of a love long buried.

*

The ether used as anaesthetic, more correctly known as diethyl ether, has narcotic and analgesic properties. It was first synthesised in 1540 by Valerius Cordus, who gave it the name 'sweet vitriol'. A colourless, highly flammable liquid at room temperature, it vaporises easily, so it may be either swallowed or inhaled. Ether was the first effective general anaesthetic to gain widespread acceptance, although long before it was put to medical use it was popular as a recreational drug. The use of ether during surgical and dental operations did not begin until the 1840s, and it soon replaced chloroform as an anaesthetic for surgical operations, and to relieve the pain of childbirth. But its volatility made it dangerously flammable, and explosions were a common hazard in operating theatres. It has since been replaced by non-flammable halogenated ethers, which are still used in surgical anaesthesia today.

My mother took her pills to numb the ravenous fear that gripped her whenever she could not make contact with me. For years she had called me ten, twenty times a day, until she made contact, and then would have nothing to say. I worked irregular hours, was often away from home travelling to install exhibitions or guest teaching. Like many artists on a precarious income, I lived in shared flats well into my thirties, and managing my mother's phone obsession was difficult. In the days before ubiquitous mobile phones, exasperated flatmates would have to disconnect the landline and have stern words for me when I got home. It was hard to make them understand, harder still to implicate them in my family situation. When the phone was out of order for a day and I had not realised, I was wakened early

in the morning by two policemen despatched to find me. This was not an unusual occurrence. When confronted, my mother did not seem to think this an excessive response, as if temporary uncontactability were a criminal offence. Eventually, I had to make a stand. I did not give her my new telephone number the next time I moved house. Instead, I told her I would call her, every Saturday morning at half-past ten. For years, in spite of her repeated pleas, I stonily refused her either my landline or my mobile number. The arrangement allowed me to manage the situation, and meant focusing all of her telephone anxiety on this one moment rather than spreading it through the week.

The actual call was minimal, a check-in I had to perform to make my father's life bearable. I gave as little information as possible. If I gave her names of friends, colleagues, work-places, she found their numbers and called them, displaying a resourcefulness and tenacity she seemed unable to apply anywhere else in life. Sometimes I would be travelling, but wouldn't tell her, to avoid having to manage her fixation on knowing exactly where I was at all times. I had always to prioritise calling her as soon as a train arrived or a plane landed. This had meant not lying exactly, but economy with the facts. I made nonchalant-sounding calls from, at various times, Turkish markets, Thai internet cafes, Italian phone boxes and, twice, trying to sound bright, from a hospital bed, each time giving nothing beyond the bare minimum: I was alive and well enough to speak, and would call again at a later, clearly specified time. It meant I could not share things with my father, or lean on either of them in a crisis, but it was the only way to contain my mother's need to

control me, and to minimise the fallout for others if I triggered her panic. So for nearly two decades, without fail, no matter where I was or what I was doing, I made the call. Every single Saturday at 10.30 a.m., on the dot.

But one such morning I had unexpected visitors arrive at exactly that moment, friends I had not seen for some time. We got to talking and it was not until after they had left that I realised the time. 11.15 a.m. Gripped by guilt and apprehension I immediately dialled my parents' number. My mother picked up instantly, breathless with panic, in such a state of agitation she could hardly speak. I told her I would come and visit the next day. 'Good,' she said, and hung up. When I arrived the following day my father was sitting alone, waiting for me in the sitting room, looking tired and shaky. My mother had still been so agitated after she put down the phone that she had taken a handful of her pills to try to calm herself down.

'I couldn't rouse her,' my father said. 'I thought she was gone. I had to call an ambulance. She's okay, but they kept her in overnight.'

'Why didn't you call me?'

'What could you have done?' He shrugged. 'The hospital just rang. She's slept it off. They say we can go and pick her up now.'

At the hospital my father and I walked down the long ward. My mother was at the far end, sitting up in a chair by her bed, scrubbed pink by the hospital staff, dressed in clean clothes, with her hair washed and fluffed up around her head. She smiled brightly as she saw us walk in. She looked like a sweet, white-haired little old lady. Like other people's

elderly mothers, like the elderly mother she might have been, had we had different lives. She sat up, beaming at us, ready to come home. She did not look like a hostage-taker.

'They asked me if I wanted to end it all, but I said no! I've got too much to live for!' she told us.

I never called late again.

Ether is numbness and sleep. But it is also analgesic. It is kind. Not a cure, no, but a respite. A chance to rest and re-gather. We hear so much of the attentive kindness of women, how we look after, care for, listen, nurture. But I would speak also for the kindness of men, to which I owe so much, the kindness of men that does not crowd and fuss, that does not need to talk and talk and talk it through, that does not look at you deeply with sad and sympathetic eyes, but is a companionable kindness that walks alongside, both of you, side by side, looking out towards the world. My father's wordless kindness knew that what I needed, sometimes, what we both needed, was to go out in a little boat onto wide, shining water and be under the open sky, among hills, rocks, birds and water, to breathe the breezy air, feel sun and wind on our faces, and return calmer, stronger, steadied.

My father and I, now and then, when the weather was fine, took a day out on Loch Lomond. We'd drive out to Balmaha and hire a little boat from Macfarlane's boat-yard. My father gave Mr Macfarlane a fiver and he would show us our boat for the day from the row lined up at the low wooden pontoon, each boat named for a bird: *Robin*,

Teal, Mallard, Whaup – the Scots word for curlew. They were old, heavy, wooden rowing boats, thick with layers of varnish, low to the water. Built to last, my father had been hiring them since my parents first came to Glasgow in the 1950s, and several of these same boats ply the loch to this day. We'd unload everything from the car, carry it down the wooden jetty and drop it into the boat: the canvas rucksack with a frying pan handle sticking out the top and the pockets bulging with burgers, salad, hard-boiled eggs, a blackened tea kettle, a rug for Poppy to lie on, the lorry tyre inner tube that was my father's only nod towards safety.

'A great day for the loch,' I say to my father as he clamps his ancient Seagull outboard engine to the boat's transom. 'Sun's splitting the rocks,' he says. He picks up the starter rope, tucks the knotted end into a notch on the flywheel, coils the rope around two, three times and gives it a sharp yank. The old motor sputters into life, and as he turns the throttle I untie the painter, drop it at my feet and stow the heavy oar I used to push us off the pontoon. The dark water laps gently at the motor cruisers moored in the bay. A swan admires himself in the gleaming midnight blue hull of a yacht my father says belongs to a well-known Glasgow crooner. We putter slowly out of the bay, the sound of the two-stroke engine bouncing off the hulls of the bigger boats as we nose our way out through the moorings and around the first island, commenting on the weather, the number of people around, the water level. Once we are clear of the moorings my father opens up the throttle and we head up the loch to 'our' island. Poppy sniffs the air, front paws on the gunwale, tail fluttering like a golden ensign. I sit right

in the prow, hunkered down out of the wind. Conversation is drowned out by the noise of engine and wind, reduced to shouts and pointing: 'Ducks! See 'em?'

'Yeah. Mallard.'

As we move out into open water I feel as if I am getting lighter. School desks and the gloomy basement of our house and my mother by her telephone: all recede, rolling away from this moment like the wake we leave behind us. The solid clinker-built sides of the little boat curve around us like two protecting hands holding us cupped over the deep black water, itself cupped by dun mountains. Sunlight pours down on us and the wind blows all thoughts away. Everything but this bright moment is evaporated by sunshine and wind, as the white clouds drag their shadows across Conic Hill and pools of sunlight ripple down over the broad and reassuring shoulders of Ben Lomond.

My father is sitting in the stern with his hand on the tiller. His shirtsleeves are rolled up. The hair on his freckled arms is pale in the sun and he is squinting ahead. He points and explains, tossing out the names of trees and birds as we go. He points out the dark yew trees studding one island, explains they were planted centuries ago because the springy timber was good for making bows. He tells me the name of another is Inchcailloch, 'island of the old women', named for the nuns who once lived in the now ruined priory. He points out how the land to the south is green and rolling, and to the north the mountains stack up, one behind the other, because the loch sits right on the fault line between Highland and Lowland.

Native woodlands of alder, willow, aspen and oak,

bluebells, heather and blaeberries that would once have clothed all the hills around now crowd only the little islands that pepper the loch, right down to the shingle beaches. As we approach our favourite little bay we check there is nobody else there. My father cuts the engine and lifts the propeller shaft out of the water to avoid the rocks. Here and there, white quartz pebbles shine like amber through the peaty shallows. Impatient, Poppy scrambles and leaps out of the boat with a lurching splash and swims eagerly ashore, shakes herself dry, snorts water from her nose and starts snuffling in the undergrowth. As the boat beaches I jump out, tug it further ashore and tie it to a tree root curling out of the shingle. We make a fire, brew tea, fry burgers, hang some sausage meat for the dog on twigs to cool as she watches, rapt and drooling, while we eat our own lunch. We explore the tiny island, then, as the sun moves round and we find ourselves in shade, we set off again for another island, to find another bay still catching the sun.

At the end of the day we nose gently through the narrow, twisting channel between two islands, where damselflies weave and dip among the sedges like blue jewels in the low evening sun, and, just once, I heard a capercaillie. It is my job to look out for the rocks and branches that rise spook-ily from the brown depths as we approach the shallower water, and if necessary warn my father to lift the propeller. One very dry summer the water level was so low we almost grounded and I had to jump out of the boat and pull it, my bare feet sinking into the velvety silt and tickled deliciously by the stubby grass growing through it, and then haul

myself back in over the side when we reached deeper water again. Whenever we get home from a day on the loch I sniff at the biscuity scent the sun and wind have left on the backs of my hands. The very particular, sweet-smoky smell of a Loch Lomondside campfire clings to my hair and pullover and I don't wash it off.

At weekends, if the weather is fine, my father loads the boot of the car with a chicken in a roasting tin still hot from the oven, wrapped in blankets to finish slow cooking as we drive out to Aberfoyle to eat our lunch in the caravan. I spend the afternoon mooching around the hillside, tapping at the gauzy balls spun around the heather tips to make the tiny red spider mites inside run around in a frenzy. I search for the fat hairy caterpillars that roll up in a ball in the palm of your hand, and pick the tiny, sharp-sweet blaeberries that make your tongue go purple and stain your fingers. In hot weather I listen out for the seedpods on the broom popping open. The smell of bracken rises all around, the green, yeasty, fungusy smell of the west of Scotland in summer, when everything is damp and lush as a jungle.

When dusk comes I stand outside with my eyes and mouth screwed shut to be sprayed with midge repellent that stings if you rub your eyes and tastes foul; but makes it bearable to stay outside. There is a little cupboard above the table in the caravan, full of bits of balsa wood, scalpel blades, pins, glue and sandpaper of various grades. We build little planes, test fly them over the gorse bushes, trim them with pennies to balance them. My planes usually nosedive or flip over and stall, but my father makes a tiny biplane no bigger than his hand, with propellers that actually spin

when it flies, and a miniature Concorde that goes like a beauty if you launch it with just the right flick of the wrist.

Later, we sit inside the caravan with a tiger tail burning, its sweet smoke keeping the midges at bay. We watch *The Two Ronnies* on the little black-and-white portable television, and the windows of the caravan are crammed with midges pressing themselves against the glass as the light fades outside and the gas lights hiss quietly. Sometimes I get my box of paints out, fill a jam jar with water and spread my paper on the scratched Formica table that has a pattern on it like clouds or marble. Once, I'd lost my paintbrush, so my father took a small twig, snipped off a bit of his hair and tied it to the end of the twig with black thread. The hair had a bit of curl to it, which made it tricky to paint with, and I had to keep rolling stray hairs out of the wet paint with my fingertip. But I knew that paintbrush for what it was. It felt like love, and everything I painted with that brush was stained with it.

But my mother isn't in the bright, remembered moments like these. She is in the spaces between them. Most of what we call our life is not found in the stories we can tell, the narrative thread of incident and anecdote we use to define our self. It is the numberless forgotten hours, the dark matter of the humdrum everyday now sunk away in forgetfulness, all the lived moments that burned in the instant now gone dim, but still there, dark ballast to the shining present.

CLEARING

Clearing: an opening or space between; the act or process of **clearing out**; or of **clearing up**, making something understood that has previously been obscure; the settling of accounts.

It has taken nearly three years of sorting, re-homing, clearing, dumping, re-roofing, re-plastering, sweeping and cleaning, but finally our parents' house has been made ready to put on the market. It's still run down and in need of further work to make it properly habitable, but it is, underneath it all, a large, gracious house in a neighbourhood that has become fashionable again in recent years. The house sold fast, in less than a week, and the date of entry for the new owner has been set for just before Christmas. I have made a final trip, on this wet winter day, with no other purpose than to take one last walk around the empty rooms and take my final leave of the place.

Glasgow rain is like no other. It imbues the whole city with its all-pervading sogginess, especially at this, the

darkest time of year. An umbrella is useless in this fine and drenching rain. It doesn't seem to fall. It simply hangs, soaking the air, clinging to my hair in tiny beads, and my coat is quickly damp through. It's almost noon, but there is an undersea gloom to the streets. Cars all have their headlights on. The heavy sky is a wet sheep's fleece, grubby and sodden. The light is completely flat and shadowless, giving no clue as to where the sun might be located. The sandstone buildings have dark streaks running down their façades and the pavements have a greasy sheen.

As I walk along the street I can see down into the brightly lit basement windows of the house next door to ours, built to an identical footprint; each house in the terrace is the mirror twin of the one beside it. The lights are blazing in a gleaming open-plan kitchen with a broad, inviting dining table. A young woman is mopping the already spotless cream-coloured floor tiles. It looks warm, safe, clean, affluent and orderly. Just a wall's thickness away from my parents, such lives unfolded. I expect our old house may soon be transformed too, polished to gleaming like this one. Better loved and cared for, I hope.

I slip my key into the lock for the last time. It's so worn it slides in smoothly. Making the long-familiar movements that my hand seems to perform of its own intelligence, I wonder if this is the very same key I have carried since my schooldays. Quite possibly. As I walk into the house I realise I am not quite sure what it is I have come for. There is nothing left to do now, no final tasks. I'm not even sure if the place still legally belongs to us. But I still have my key, and I needed to come back, just one more time. It's as if I have

lost something and have a feeling I might have left it here. I don't know what it is that I keep looking for, something I have left or lost, something that feels like it *must* be here somewhere in these empty rooms. So I keep coming back to look for it in the same places, just as when I have lost my car keys or glasses and keep patting down the same pockets again and again, my eyes returning repeatedly to the same spot on the shelf even though I already know they are not there, as if I can't believe they aren't where they should be, where I always put them.

But everything is gone now. The floorboards are bare, swept and mopped by the team of professional cleaners my brothers and I paid to come and do a pre-sale deep clean when none of us could face it any more. I see that one of my brothers has been here since my last visit and left a bottle of champagne and a welcome card for the new owners to find when they first open the door. A nice gesture. I walk down the hallway, my footsteps clumping loudly in the emptiness, and try to squeeze a last few drops of understanding out of this house. The smell has changed, but there is something familiar about it, coming back from a very long time ago, from a time before the sadness and the dirt, a warm, woody, biscuity smell that's emerging now that the carpets and furniture are gone and the damp is drying out. I go down the stairs into the sitting room for the last time. Coming down these stairs for the first time, when we had just moved in, is, I think, my very earliest memory. The banister was about level with my head and I was holding on to it tightly, stepping carefully down the stairs behind my brother. I heard him say 'Ew, look at that horrible wallpaper!' and I repeated

him, parrot-style. He was right. It was horrible. For some reason I remember that wallpaper very clearly, nicotine-yellow with tiny diamonds on it the colour of dried blood, still there, I suppose, hidden beneath several layers of paper and paint. There was then, as now, a sensation of diving below an invisible waterline, a subtle holding of the breath, sinking below the road level into the relative gloom of the basement, the daylight filtering greenish through the leaves of the privet hedge and the small lawn that sloped steeply down to the low-slung windows. Every time I have entered this room, as each step lowers me down, I have peered into the dimness as my head clears the ceiling and my eyes adjust, ready to judge my mother's anxiety by the thickness of cigarette smoke, to hear her greeting: 'You're late!' and my father's 'Oh, hello!', always as if taken by surprise.

My father was frustrated and trapped by my mother's illness, habitually resentful and surly with her. But my mother's loyalty to him was absolute. When she was just beginning to struggle with walking, and my father had gone out to the shops, leaving me to keep an eye on her, she said to me, 'My legs are bad, but it doesn't hurt. Dad's knees are sore.' She felt compassion for him and knew he was hiding the increasing pain of his arthritic knees from me. I had to get each of them alone to hear what was really going on, how much they were struggling. Together they were impregnable. When I visited, I would try to go out for a walk with my father. We would go somewhere in the car, just to a local park usually, and walk a little, sit on a bench for a bit, chatting about this and that, and he would start to tell me things. He would tell me how my mother had fallen and he tried to catch her and they had

toppled to the floor together; tell me how my mother had got up one night and fallen and he had found her lying there in the morning, half frozen in her thin cotton nightdress, unable to get up; tell me he was having to strip her bed of wet sheets in the morning. But he wouldn't accept any solution or suggestion I offered, always shrugging me off.

But sometimes I did have to intervene. I came to visit them both one Sunday a few years ago to find a pile of blankets on the floor beside my mother's chair. I asked my father about them. He said my mother couldn't get up the stairs any more, so he threw a blanket over her at night and let her sleep in her chair. I was horrified. 'You can't just leave her there!' My father was intransigent. He seemed to think this was perfectly acceptable. Later, he went out to the shops on an errand and I stayed with my mother. She was awake, cigarette in hand. 'Will you call the nurse?' she asked me, after my father had left. She had been due to go for some mundane but important check-up or minor treatment, her ears I think, but it seemed my father had not made an appointment for her. I picked up the phone to call the local surgery, but I didn't ask to speak to the nurse. I asked to speak to my mother's GP. With my heart pounding, I told him that my mother couldn't walk unaided now, that she needed some assessment, some physiotherapy, a walking aid at least, that they were not coping any more, that some intervention was needed. I put the phone down. I was afraid what would happen next, but I knew something had to change. The next time I called home, my father told me that my mother had been admitted to hospital for 'rehabilitation' to improve her mobility.

At first, my father made himself visit her in the hospital twice a day, every day, bringing a change of clothes as requested by the nurses. After a couple of weeks of this my mother looked brighter, cleaner, and was more communicative, rather enjoying the attention and the bustle of activity around her. But my father was exhausted, and annoyed with me for interfering, causing him all this disruption and stress. In hospital my mother was learning how to walk with a frame, the physiotherapist encouraging her to venture a little further down the ward each time. She had a stomach bug, which ran through her in twenty-four hours. My father caught it too, but he struggled on with it for days, still doggedly visiting my mother twice a day. Then a routine check-up ended up with my father also being admitted to hospital, to treat an infection. I had to jog across the sprawling hospital grounds to catch both wards' visiting hours. But it also gave me a chance to get into the house with neither of them in it. I hadn't been alone there since I left home at seventeen.

I took the week off work and, between hospital visits, went to the house armed with bleach, rubber gloves, scourers and mops. I scrubbed the walls, the floors, the kitchen shelves and cupboards, stripped the beds and threw away the stained bedding, cleared the cupboards of out-of-date food, pulled soiled clothes out of the corners they'd been stuffed in and put them through the wash, dragged bagfuls of junk to the communal bins in the back lane, poured bucket after bucket of grey water down the drain, and still the place didn't look any better. For five days I scrubbed as if I could scour it all away, rinse out all the sorrow

and frustration, smooth fresh, clean cotton sheets over everything.

My father was in hospital for just a few days and then discharged. My mother was kept in for six weeks in all, while we made arrangements for a stairlift to be installed, grab handles fitted, booster cushions on the chairs to make them easier to rise from. My father and I discussed these adaptations as if they were all for my mother's benefit, but the changes made a real difference to both of them, made it possible for my mother to get up and down stairs again, eased the strain on my father's painful knees, made another few years in that house possible for them both. But after that, I held back as much as I could from intervening again. It would not be welcomed. I knew my father would want to hold on to his pride and independence until the very last.

I open the door to his workroom. It's now just a bare and shabby box with a low ceiling and bars at the window. All signs of him are gone, I think. But then I spot a piece of cable glued firmly into a hole cut into one of the window-panes so he could connect to an antenna on the roof, a clue that the new owners will not recognise. The faint pattern of 1950s wallpaper still shows through the whitewash my father hastily painted over it decades ago. I turn to leave but my eye fixes on the soft brown smudge on the wall around the light switch, left by the repeated passing of his hand, year after year. The family who move in here will see only a grubby mark. But I see my father's hand reaching for the light switch as he leaves my mother sleeping in front of the television and goes into his room, turns on his radios, puts on his headphones and listens to the crackle and hiss of the

universe, builds another model plane, tests the balance of its wingspan on a fingertip.

Memory is not just in the mind. It lives in actual places, in actual things. It sits in empty chairs and in worn carpets and smudged walls and light switches. I stand close to the wall and rest my own fingertips against the mark my father's touch had left, a final intimacy, the closest I will ever get to his physical presence again. I can almost smell him. A sudden ambush of grief falls upon me, heavy as surf. Pinned down by it, I lean my forehead to the grease-marked wall, sobbing hard and repeating 'I'm sorry. I'm sorry I didn't talk to you. I didn't help you enough. I'm so sorry.' The wave leaves as swiftly as it came. I wipe my eyes, leave the room and close the door behind me.

In the middle of the stripped-out sitting room I stand in the space my father's chair occupied. Where once I was so sharply aware of my parents' absence, now it's the absence even of their absence that seems to fill the room. The walls have been re-plastered up to shoulder height but remain unpainted, and the floorboards, rotted by damp at the ends, don't quite meet the new walls. There is a building site feel to the place, a 'blank canvas' for the new owners. But it's not blank to me. I step across the room to where my mother's chair once sat, to one side of the gas fire. The only trace left of her is the dark nicotine stain on the ceiling, which has its epicentre in this corner. I notice how, from here, she would have been able to see through the hedge to watch who came along the street, who turned up the path to the front door. She would, in the same glance, have also seen the clock on the wall. She would have seen me come up the path, my legs

appearing as I came downstairs. From her safe corner she could watch everyone come and go.

I try to grieve for her in the nicotine-stained ceiling as I had for my father in the mark his hand had left on the wall. But I am blank, as always. It is over. I did my grieving for her a long time ago. The loss of my mother was not sudden. It was slow and ambiguous and my grieving for her lasted decades. I had ridden out the big, slow-moving waves of sadness and anger as they passed through me, the occasional storms of furious, frustrated weeping after some crisis caused by her panic, and the long grey periods that followed them, when joy was hard to find. I should welcome the calm that is upon me.

I walk around the other rooms one final time, staring out of each window in turn, closing each door behind me. Whatever it is I am looking for, it isn't to be found here now. Maybe it never was. All that I could not be for them, and all that they could not be for me, all our human failings, the deep silence heaped over love through the long years we moved around each other in this space. Tidying up the house has not tidied up the past. The house still feels like an accusation. I did not love them well. There will be no amends, no neat 'closure'. It is over, simply that. They are gone. This house belongs to someone else now. I'm tired of it all. Just tired of it. I turn to go, suddenly decisive. I'm glad the place has been sold. I'm glad the rotten window frames and mildewed wallpaper are someone else's problem now. I'm glad that I will never have to come here again. I'm tired of the way this house always feels so heavy with old sadnesses that close in around me. It's time to go. Life happens.

Sad and bad things happen. People try to love each other and do a ham-fisted job of it, mostly. Love, in a family, is not always how we might wish it to be, for we do not choose our families. But it shapes us nonetheless, knocks us into and out of shape, year after year, as we, in our clumsiness or carelessness, trip and bump against each other. That there was love in this house I do not doubt. But we handled it without skill. It wasn't their fault. It wasn't my fault. It was nobody's fault. I pull the front door closed behind me, listening for the last time to the long-familiar sound of the latch snapping into place with a metallic *chunk*, and, without looking back, I walk quickly up the street.

I couldn't fix my parents' situation as an adult any more than I had been able to as a child. If I couldn't change things, I had to learn how to stay with this difficulty, neither ignore it nor endlessly fight it, but not be overwhelmed by it either. I needed to find a way to keep my balance in the middle of it all, for my own good, and for theirs. So I began to learn to meditate, to sit still, in silence, and watch my breath. It sounds simple, and it is simple. But it's not easy, to sit still and watch the breath while thoughts spin and tumble, to sit and watch until the mind's movements begin to slow enough for you to follow how a thought moves, how it feels almost muscular, like an involuntary twitch, how it trails behind it an emotional comet-tail of feeling, to sit and watch how those feelings press and pull at you, without responding or resisting them, just taking a friendly interest in it all, to sit and watch how a thought rises, loses energy and dissipates, and then to keep watching the space it leaves behind once it has gone. It's an open space, clear,

and luminous. I get only a glimpse of it, now and then, but I know it's there. I meet something in that silence between and behind the endless commotion of thoughts and feelings. It's a calm kind of happiness that doesn't need anything much, just a quiet place to sit.

Now that the house has been cleared and sold, a space opens up in my life that had, for the last couple of years, been filled with the business of getting to this point. I am tired, and take some annual leave, but instead of going on a holiday, I attend a short but intensive meditation retreat at a Buddhist monastery. I'm there for ten days, seven sessions a day, every day, starting at 5.30 a.m. and ending at 8.30 p.m. with attendance of every session mandatory. Every morning I make my way through the dark monastery grounds to take my place on a cushion among hundreds of other retreatants in the crowded temple, and gaze blearily up at the rows of golden Buddhas at the shrine end of the hall, the gorgeous tankha paintings hung from the walls, the ornately carved pillars and arches, the rows of red-robed, shaven-headed monks and nuns sitting still and straight-backed up at the front. Then, as the gong sounds, I settle down in the gently soporific hum of the electric prayer wheels for another session.

Every morning of the retreat I sit and observe my mind as it careens around like a wild horse trapped in a corral. It can take all day for it to even start to slow down, never mind become still. By the evening session I am swimming in drowsiness, yet still the thoughts keep galloping tirelessly in their circles. Their sheer energy and persistence is impressive, if frustrating. Five days in and by mid-morning

my whole body aches from sitting. My knee hurts, my foot has pins and needles, my right leg has gone numb, and the compulsion to move overwhelms my wish to remain still. I move my leg little, and relief floods in. But a few minutes later it starts up all over again. Discomfort, compulsion to move, a shift of position, a flood of relief, needling discomfort again, compulsion again, fidget again, relief again, on it goes, round and round. I recognise what our teacher has described, a tiny and perfectly mundane example of the 'wheel of Samsara', the endless cycle of desire and suffering that Buddhist practitioners of meditation seek to break. So, on one afternoon session, I decide that I will conduct a small experiment. I am simply not going to move at all, no matter how much I want to. I will try to just step off that hamster wheel of always wanting this and not wanting that, and see what happens.

The gong that begins the next session sounds, and within a few minutes my hip starts to hurt. It's not life threatening, nor even terribly acute, just a dull throb, but soon there is a very strong compulsion to move, a pushing urge that, thwarted like this, rapidly turns to frustration. I don't move. The pain grows. The compulsion grows. The frustration grows. They swell to fill my whole mind until I am completely gripped by discomfort and the urgent desire to move. Fascinated, I keep watching. Anger starts to build. I feel it shooting upwards through my body in little petulant bursts of rage, from the base of my spine up towards my head. It feels hot. My cheeks start to burn and I wonder if they are turning red. It feels as if my head has become a Roman candle as hot rage fizzes up through me. I'm shocked

at how much of a spoiled brat I am, how much rage lurks just beneath the surface calm, how explosive and selfish this anger feels. Little spasms of petulance are making my whole body twitch slightly, like electric shocks, though I am trying to keep still. Something inside me is throwing a full-on toddler tantrum.

A sense of the ridiculousness of it all, of sitting on a cushion obsessing about my aching arse while others around me are, presumably, sending waves of compassion out to all sentient beings, brings with it a fresh breeze of humour. Amusement opens up a chink of space around the whole self-generating micro-drama. My mind stops gripping quite so tightly. The pain and the compulsion immediately abate. Then someone's watch beeps the hour and for a moment I think time's up, but then I realise that no, it's not over yet. I have another half-hour to sit through. It seems like an eternity. Panic floods in, I can't do this! The compulsion to move beats its little fists furiously. A knot of fear forms in the middle of my chest and my palms sweat. Suddenly I want to cry with frustration.

But it's also fascinating to watch the power of the mind and what it can make me feel and do, to observe the energy and power of emotions without reacting to them or indulging them. The young woman immediately to my right is sitting perfectly still. I don't want to disturb her. I lean on her stillness, take strength from it, turn my ego's pride against itself – if she can do it, I can. I watch how my fear doesn't move fast like anger does, but lodges itself like indigestion, churning over and over, obsessively repetitive, cold and heavy. I notice how fear's root is the same as that of

anger: I don't want this! Except it wants to run away rather than stay and fight. I notice how my aversion seems to lend power to the very thing it doesn't want – the pain swells and ebbs according to how much my mind is occupied with wanting rid of it. When I manage to allow some space around the pain, maybe even laugh at it a little, it seems to not quite lessen but become less engulfing, just there, not such a big deal after all. In fact it's quite useful – it's keeping me wide awake and intensely alert, not at all drowsy. The anger flares up again, like a blast furnace. Come on! Enough with this now, really! *Just move!* And then, abruptly, all the struggling is gone. Suddenly everything is utterly sharp and clear. I am acutely aware of everything around me, intensely alert, like I've had a hit of amphetamine. Instead of being cramped inside my skull, latched on to pain, my mind feels expansive and I see everything with etched clarity, like being at the summit of a very high mountain in crystal-clear air. For a moment. Then I quickly tip back into the usual whirl of banal thoughts, about lunch, about the queue for the toilet and how long the break will be, and the fog closes in again. Stability takes years of diligent practice. But I had a glimpse.

I wonder if my mother ever saw past her narrow fear to something open and bright. I think of Agnes Martin, a woman who suffered a lifelong mental illness, but who found her way through it to make incandescently joyful art. Martin began her career in New York, among the macho abstract expressionists of the late 1950s. She quit the city in 1967, just as her work was gaining critical acclaim, and vanished from the scene. It may have been a diagnosis of

schizophrenia that prompted this, and no one knows for sure what she was up to in that period, but five years later she re-emerged in the New Mexico desert. She lived and worked there until the end of her life, making occasional road or boat trips out into wide-open land or sea horizons. Until her death in 2004, at the age of ninety-two, she practised a daily discipline of painting, and the ability to be in a rich solitude, living and eating very simply, much the same things every day, so she wasn't distracted from her work.

There in the desert she painted spare, square paintings, delicate grids of fine pencil lines applied directly to usually white canvases. They are so subtle that photographs in books do not do them justice. In small reproductions her grids seem dry and repetitive. It was not until I happened upon one of Martin's paintings in a museum in New York that I understood. In a room full of brash abstract expressionist paintings was one pale, square canvas that seemed to shine as if lit from within. It pulled me across the room and I stood in front of it for a long time, rooted to the spot and at the same time feeling opened out, as if glimpsing some immense space I might expand into. I was startled by the effect it had on me, this humble, plain painting.

So, not long after the retreat, when I hear there is to be a major retrospective of Martin's work at Tate Modern, I make a quick trip to London, just to see it. Seen in the flesh, full size, the discipline of Martin's grids is not harsh but delicate, intricate handmade graphite lines finely blending into shimmering veils of soft grey, like looking into a fog. Sometimes she used wide bands of pale blue or pink, as if the bleached light of the desert was still falling across the

white canvas, hot and dazzling. Always the same square canvases, the same modest means, the same feeling of humility and calm. Martin said, of her grids, 'I can go in there and rest.'

One room of the exhibition is filled with the twelve square paintings of a multi-panelled work Martin called *Islands*. As soon as I walk into this room I give a little quiet gasp, and as I stay longer a wordless joy blooms in my chest. I feel it pressing outwards and upwards, like a rose opening. It's very rare that a painting brings tears of joy, but these lift me up like a song. My eyes start to fill, and I think, Yes, this, just this. It's enough.

I stay for a long time with these twelve 'islands'. Sitting on the low bench in the middle of the room, I consult each painting in turn, giving each one my full attention. I lose all track of time. Everything else falls away. These are plain paintings, even by Martin's standards, square and white, with subtle bands of palest grey underpainting, and an air of absolute silence.

A square is content. It doesn't need anything. It rests within itself. Each painting here is as plain as a nun. They are still and contained, and yet seem to hum with energy, as if Martin has found a way to paint the luminiferous ether itself, to paint light and formlessness, to paint attention balanced on the head of a pin, to paint the bright, open space of the stilled mind. She was right about the square, the grid, yes, you can go in there and rest. I look at these canvases and find myself thinking, I am so glad these paintings are in the world, so glad this artist found her way through suffering to make them. I am so filled up with gratitude I

want to tell someone, like it's spilling out of me. But people drift in and out of the room, not really seeming to be much impressed, glancing around, not paying much attention. A woman sits by me for a few moments, ignoring the art around her, peering instead into her bright little screen, tapping and scrolling, tapping and scrolling. I want to say gently to her, Please, put that away, look up from the screen, just let yourself be still, let your mind settle, and then these paintings will shine for you. They will shine with such a calm, plainspoken joy that you too will be grateful, and will go smiling out into the day.

Eventually, I leave the gallery and return to the hubbub of central London, feeling opened out. There is room for everything, all of it, I think, as I head for the Tube.

AURORA BOREALIS

*When we venture into knowledge and science, we
do so only to return better equipped for living.*

Johann Wolfgang von Goethe

With the sale of my parents' house completed, the new
owners have moved in. The house has slipped, quite
suddenly, into the past tense. For forty-five years it was an
unloved house in which our family was quietly unhappy,
each of us in our own way. For the three years that it
belonged to my brothers and me, it felt like a heavy weight
to carry, a constant source of worry, an endless list of jobs
to be done and eye-watering bills to be paid. But with its sale
it becomes a financial windfall, the possibility of change, an
open door. I am restless in my job, tired of my pressured,
busy lifestyle, and ready make some changes, but not yet
sure what form these might take. So when I am invited to
spend three winter months on an artist's residency on the
far north-east coast of Scotland, I jump at the chance.

It has been a long time since I have undertaken a resi-
dency like this. My memory of being sick and alone in Basel
made me avoid pursuing that kind of opportunity for a long

time, and then a full-time job and frail parents had made it trickier to get away for an extended period. But this time it's a welcome respite from the endless train commutes and the feeling of hectic over-commitment. I hadn't realised how tired I was, pulled for so long in so many directions. Here, I can stay in one place for a while, far from any major cities, and gather myself together in quietness, reflect on what has passed and consider the future, while the house I grew up in slips away into memory. It seems fitting, too, to head north-wards into the winter's darkest months. There are things I still need to understand about my mother, and I have a sense that the darkness of the Highland nights will be good to think with. I hope to see the northern lights too, the aurora borealis. I should be far enough north and far enough away from urban light pollution to have a good chance.

Just after the new year I step off the train with my suit-case, laptop and camera, and three months stretching out before me. The North Sea lies to the east. To the north and west lie mile upon mile of rough hills and blanket bog. This place's centre of gravity, the cold, black River Helmsdale, cleaves through the middle of the houses and shops that have gathered where river, sea, road and railway all meet and cross each other. The weather is biting cold, the roads icy, the daylight short. Evening closes in early around the streets and a huge, velvet-black night unfolds just beyond the streetlights. This is a good place and season to think about darkness and hidden things. The residency flat is small, plain, comfortable and contained. It has no phone or television. The view from the window is not too distracting. There is a desk and a chair, facing the wall. It's perfect.

I am content to fall in with the season's introspective ways, quiet and solitary, regular in my habits, submitting to the steady discipline that creative work of any kind requires. With few distractions, I adopt an almost monastic routine. In the mornings I set my alarm so I can get up in time to walk down past the harbour in the pre-dawn dark and watch the sun rise out of the sea. On the first morning I only just manage to get myself up and out of the door in time. Lying in bed thinking up good reasons to stay there just a bit longer (my lingering head cold, my long journey the day before), I hear a shrieking commotion outside, like a flock of parakeets, and peer out into the gloom to discover that the school bus stops just outside my front door. A gaggle of school kids are excitedly scraping up little handfuls of the thin layer of snow that fell in the night and flinging them at each other. I think, Well, it may still look like the middle of the night out there, but if they're all up and about I better just get on with it. So, hatted and booted and gloved I hurry down to the river mouth and along the shore, past the little harbour. The snow is just thick enough to creak under my boots. A council worker in a hi-vis vest is scattering salt and grit on the pavement from the back of a truck, flinging it from his shovel with practised, rhythmic movements.

You get to know grey in Scotland in winter. Either you make yourself miserable wishing for summer's saturated hues, or you embrace grey in all its endless subtleties. Once you relax into it, grey becomes fascinating. And beautiful, really. You can get to love grey. It can hold all other colours within it. Grey has lightnesses and weightings, delicate infusions and dark stainings, densities and foggings. The

pre-dawn sea is a deep greeny-grey with a faint sheen, like wet Welsh slate, the sky above becoming a soft, matt purply-grey as the light grows. The hills are covered in last night's snowfall, speckled with black and brown where the rocks still show through. The peaks nudge up into clouds of dove grey, pearl grey. Pearl? No. Something less rarefied and precious. These clouds are home-grown, and Scotland produces endless local varieties that ripen in every season. These heavy, solid winter clouds are grey like the rain-clogged, matted fleece of an old Blackface ewe, here and there thinning to thistledown where a few wisps break loose and drift away, like strands of fleece caught on barbed wire. These are mashed-potato clouds, stodgy and familiar, almost comforting. I try to pay attention, watch the dawn light as it changes, but I'm getting cold. My ear hurts and the wind scrubs at my face, and my nose is running again.

Just when I am thinking that I hate winter mornings, that they're so deadpan, that I'd much rather be in my warm bed, or least having a decent cup of coffee, I start to see a gleam of silver on the eastern horizon, over the sea. Quite suddenly, it brightens to a lucent tangerine. I hadn't expected to see much this overcast morning, but there it is: the sun, rising up out of the sea. The sky lifts like a hallelujah all over the east, all rowdy pinks and lavenders, frills of cloud trimmed with fiery orange. The sea turns indigo, gleaming coolly. The wet stones on the beach are suddenly each one rimmed with gold. The clouds are nacreous now, flushed with soft colours like the inside of a mussel shell. It's such an arrival, this eruption of light, I feel like cheering aloud. I give the sun a little gloved-hand round of applause, hoping

any dog-walking passers-by will think I'm just warming my hands. As the sun lifts away from the sea it gets too bright to look at directly, so I turn around and watch peach blossom pink light slide down from the tops of the snowy hills behind the village and over the wet slate rooftops of the row of cottages by the harbour.

The working day is getting under way as I walk back to the flat. Workmen are gathered around a van by a house under scaffolding, rolling cigarettes, preparing for work. A skinny youngster leans on the van awaiting instructions, his hood tucked under his hard hat, sleeves pulled down over his fingers, shoulders hunched into the cold. The low-angled rays of sunlight catch the reflective bars on the foreman's high-vis weatherproofs, and he is suddenly transformed into a golden bedazzlement, radiant as an archangel, a fragment of the sun fallen to earth. He blazes with such startling incandescence it amazes me that he and his companions are unaware of his sudden transfiguration. Then our mutual angles shift, and he is, once again, just a man in scuffed yellow overalls discussing scaffolding and roofing joists.

A big bank of cloud rolls in. Veils of rain drape across the east and close off the sun as it rises, so all that is visible down here now, in this humdrum winter world, is a gradual sharpening of contrast as the whites lift themselves up to meet the growing daylight, from soft grey on grey to stark black and white. The wind rises too, hard and cold. It finds its way through my buttonholes, bites at my ear even through my thick woollen hat. As the sun continues to lift away from the horizon the light becomes mundane, just a flat and businesslike daylight. I come back inside to

the warmth, sit down at my desk, hot coffee in my hand, and start work right away, the walk still in my body, my ears burning from the cold and my nose blocked, but the scrubbed feeling on my face making me feel energised, ready for the day.

My life here revolves around dawns, dusks and the dark of the nights. I plot the times of these carefully as they change from day to day. Winter days are very short at this latitude, summer ones very long, and so the transition between seasons is dramatic. Midwinter dusk comes early, not long after three o'clock. I pause in whatever I am doing to watch the light drain out of the ground, soak away into the heavy sky and sink down over the hill behind the village. I wipe a patch in the misted window to watch the glimmering river fade into the darkness. Or I put on my coat and boots again, to go for another walk as the afternoon smudges into grey and a thin snow goes dithering down into the water.

There are, by official definition, three twilights, not just one. The time between day and night is finely delineated according to the precise position of the geometric centre of the sun in relation to the horizon. 'Civil twilight' is the lightest, when the bright edge of the sun's disc is only just hidden below the horizon. 'Nautical twilight' is when the centre of the sun sinks to between six and twelve degrees below the horizon. During nautical twilight, details cannot be discerned, but the horizon, at sea at least, is still clearly visible, so in the days of the sextant mariners could reliably use the stars to navigate. During the third and darkest twilight, 'astronomical twilight', the horizon at sea is no

longer clear. Away from light pollution, astronomers can see the brighter stars, but not faint objects like nebulae and the dimmer stars. These are only visible when the sun sinks further still, beyond eighteen degrees below the horizon. At latitudes beyond about 48.5° north or south, which includes the whole of the UK and most of northern Europe, as you approach the summer solstice you won't experience proper night at all. Twilight lasts from one day to the next.

But in most of Europe and North America light pollution will likely mean that many of us will never experience true night, even in winter. We spend our nights in a fourth twilight, a luminous, man-made fog of permanent tungsten twilight. True night, real darkness, is being steadily pushed back. About two thirds of the world's population, and fully 99 per cent of the populations of the US and Europe, live in areas where the night sky is blurred out by electric light. We have driven darkness out like a demon. More than two thirds of the US population and more than half of Europe can no longer see the Milky Way with the naked eye, even on the clearest, darkest night.

This light pollution causes problems for wildlife, especially migrating birds, bats and insects. Moths, for example, have evolved over millennia to navigate faultlessly by the light from the moon. The rays of moonlight fall in parallel, and by keeping them at a particular angle to its eyes, the moth can find its way. But the light from a man-made point source of light, like a tungsten bulb or a candle flame, fans out in concentric rings, so the moth is confused and is pulled into a fatal spiral. Songbirds are fooled by bright streetlights into night-long singing which exhausts them

and interferes with breeding. Nocturnal creatures lose their temporal habitat, if not their physical one. Light pollution is bad for human health too. The disturbance of circadian rhythms caused by night lighting is now known to disrupt the endocrine system and has been linked to an increased risk of breast and prostate cancers. It's monstrously wasteful too. About 30 per cent of light from street lighting shines upwards, performing no useful function, but obliterating our view of the stars.

Here, after dark has properly fallen, I take long, meandering walks around the village with my camera. I take pictures of the streetlights shining onto the silent, black river, of bare trees made strange by the jaundiced glow of sodium light, of snowflakes drifting through the bright orbit of a streetlamp, of scrubby grass lit by my torch beam, and my own puffs of breath hovering briefly like ghosts on the cold air. I film the harbour lights shimmering on the sea, and the bright beads of car headlights sliding along the main road that hugs the coast. I go down to the riverbank and film the bright face of the village clock like a reflected moon in the water's glossy, swirling surface, two kinds of time, each flowing into the other. I'm not sure what I'm looking for yet. I hope I'll know it when I find it. But to do this work I know you have to feel your way forward tentatively, blindfolded and fumbling.

I decide that, while I am here, I am going to wean myself off city streetlights and become comfortable with walking in the dark. Proper dark. The deep dark of the north in winter. It seems important, as if moving through the dark outside I might learn how to move through inner darkness

and uncertainty with more ease. So tonight, after nightfall, I walk through the bright tunnel of streetlights to the edge of the village. But I pause under the last light, surprised to feel the unmistakable and familiar slither of fear come to join me. A city girl, instinctively I glance behind me, scanning the silent village street, a fist of keys in my pocket – old habits die hard. It's well past midnight now, and there are no lights on in the houses. Everyone's asleep. I let go of my keys. I can slip away into the night unseen.

From here the footpath vanishes into an enveloping dark. I step out into it, wary, my head swivelling like an owl's, blinking uselessly. I hold my breath to listen. I'm alert and on edge, senses all peeled back. Perhaps it's the transition from streetlight to darkness that feels so ungrounding, that first moment of stepping out and not seeing where your foot will land. There is no moon. It's unusually still, but there is just enough wind moving over the hills that I can hear how far they extend around me. The sound opens up the space of the night and it feels huge. I try to move quietly, but I stumble, no longer sure where my body ends, and I tread clumsily over the frosty tussocks, testing each footstep before committing my full weight. I feel like I'm crossing a boat's heaving deck, and wonder if it's possible to become accustomed to the way the unseen ground meets the foot so unpredictably in the dark in the same way one gets sea legs on a long voyage.

Once my eyes adjust and I settle in, I see it's not completely dark. Everything is touched with a faint luminosity, the airglow of starlight diffused behind cloud. After the hectic orange of the streetlights, this silvered gloom feels

like a cool hand laid gently on my forehead. I see in black and white, blocks and solids, big shapes, no detail. The gorse bushes are just dense black clumps, a bit blurred around the edges. The rounded hills above me slump heavily, darker against the charcoal grey of the sky. The ground is fogged around my unseeable feet. I make myself keep walking out into the darkness and it feels like when I am faced with a blank sheet of drawing paper or when I have written my way to the end of the last sentence where I knew what I was going to say, and know that I have to make myself keep on going, putting one word after another, because if I don't I will just keep on circling those same well-lit streets of received thought and thinly veiled plagiarism. Any creative work is a walk into the dark, moving out towards uncertainty, trusting those quick darts of feeling, the almost physical twitch of recognition, the bubble-float dip that says 'pay attention here'. Walking is as much a way of moving thoughts along a path as moving the physical body. I keep stepping forward, carrying my questions gently. There is something to discover, out here, in this wind-blown darkness. I have to wait, all senses open, observing what is to be observed, until my eyes adjust and I begin to see.

Goethe knew how to observe what is to be observed, how to watch and wait until finally he understood something about darkness and light. Goethe did not see darkness as just an absence of light, as most of his contemporaries did. He believed darkness was an active agent, and that light and dark act as opposing forces, like the poles of a magnet, interacting to create the phenomenon of colour. Newton famously shone a narrow chink of light from a shuttered

window through a prism to reveal how white light could be sliced up into the separate colours of the spectrum. Goethe, on the other hand, wanted to understand light in its wholeness, watching how it behaves as it moves in the living world, not shuttered away in darkened rooms and bent out of shape by prisms. Noting that on a clear day the sky overhead is a brilliant blue, becoming paler as it nears the horizon, and that if you go up a mountain the sky becomes violet, Goethe understood that when we look at the sky we are seeing its true darkness illuminated by the sun's light as it passes through the 'turbid medium' of the atmosphere. On the other hand, on a clear day the sun overhead is a very pale yellow, almost white in clear skies. But as it sinks towards the horizon it becomes orange, even deep red, as the atmosphere thickens and so darkens the sunlight. As the sun rises again, the atmosphere that we see it through becomes thinner, so it loses these warm, rich colours. I had watched this phenomenon unfold with every winter dusk and dawn I had observed or filmed over these last few weeks. As Goethe watched the changing sky, he understood that colour emerged from the shifting balance of darkness and light, and that both light *and* dark are necessary for colour to emerge: 'Yellow is a light which has been dampened by darkness; blue is a darkness weakened by light.'

Goethe's insight was that darkness isn't something to be eliminated, ignored, fixed or got rid of. It isn't just an absence of light. It's an active agent, interacting with light to produce the effects we see as colour. Out here on the dark hill, I keep on walking, following the track upwards, and leave the lights of the village further and further behind

me. The darkness feels as if it is swallowing me whole. As I crest the hill and drop into a shallow dip even the red pinpricks of light from the distant off-shore wind turbines vanish from view. Still I keep on walking, away from the roads and houses, away from the people sleeping in their darkened homes, following the rough track out onto the open hill. And as I do, the big, dark night breathing over the moors no longer feels intimidating. I gulp in great lungfuls of the black air, drawing it into me, this active darkness that can twist warm yellow, orange, red out of plain white light.

For most of my life, my mother has felt like a dark bruise on my heart. Darker still, denser and more hidden, is my shame. My mother was sick and I did not help her. I was young and frightened and angry, and more than that, I was cruel. I withheld the love she craved, cut and cut and cut again at the connection she hungered for, and gave her only the barest necessary access to my life. Her illness isolated my father too. I could see that he was lonely, but I could not come any closer to him without also coming closer to my mother. By keeping my emotional distance from them both, I did not help him. Although physically present, I made myself a stranger, archly polite or sometimes irritable, but never warm or loving.

The luminiferous ether, the medium through which light was supposed to pass, helped me to see that the space between my father and I was really a connection, if only one of longing, or some unspoken mutual understanding between us. The ether in the space between my mother and

I was one of a numbed distance. Of course she gave up and withdrew into herself. I had already done so years before. We lost each other a long time ago. It's not that I don't feel grief for this loss, it's that my grief is so old, has lived in me for so long, that I no longer notice it. It runs right through me like dark matter, slow and heavy, shaping my form with its weight, yet unseeable. It's a darkness my eyes have long since adjusted to. But the darkness of grief is an active agent too. The poet Wendell Berry calls grief 'the severe gift'. If I stay numb, protect myself from grief, difficulty, pain and distress, I wall myself off from joy and light and love too. The darkness enfolding me here is beautiful and spacious, and there is beauty and spaciousness in grief too. After all, it is an expression of love. I make my way slowly home again, carrying with me the severe gift of the dark hill, some kind of answer to the question I brought north with me.

As the months of my residency pass, the dark starts to loosen its grip on the season. At this latitude you can feel the planet's tilting turn as the year rolls around, sense the rapid lengthening of days as the season shifts, the light tangibly stretching out a little more each dawn and dusk towards summer's long, light-soaked days. You can feel the enormous, overturning present always falling, falling away, always coming, coming up over the horizon. The cold black river goes on brawling past my window, passing on by, huge and indifferent, always already elsewhere. The clock tower chimes out the passing of each quarter hour, day and night. On many mornings, each morning a little earlier as January gives way to February and then to March, I go down to the eastward-facing shore and wait from darkness till daybreak

with my camera on time-lapse, watching blue dark turn to orange dawn to plain day, and through all the nameless colours in between. I go down at night too, to film the moon rise, its white path smudged through scuffling cloud, blurring the stars as its light spreads a soft sheen on the dark sea.

On clear and moonless nights I point my camera straight up, a wide-angle lens to capture the whole sky, and leave it running until the battery goes flat. Next day, I play back the time-lapse, and the span of a whole night unfolds in seconds, revealing the spinning of the stars and the dull flickering of the aurora to the north, movements that I could not see with my own eyes. I edit and reverse the footage, speed it up, flip it upside down, so it's as if the ground is turning under a steady sky. Like my father's antennae, my camera and laptop become instruments of a finer observation. Yes, this is a good place and season to think about darkness. But also to notice how darkness is shot through with light, how these two are always moving in and through each other, unbalancing and rebalancing, through the days and seasons. The stillness of my night-time vigils is an illusion. Just speed things up a bit, and I see how light and dark are forever gathering up and falling away.

I'd been hoping to see the northern lights all winter, and subscribed to an alert service on my phone to let me know when one was likely. But every time an alert came in there had been thick cloud overhead obscuring any view. It's getting close to the end of my stay, and I have yet to properly see an aurora. Time is running out. But one evening my phone bleeps with an alert that there has been major geomagnetic activity and an aurora is very likely to be visible

if the sky is clear. A coronal mass ejection of plasma and geomagnetic radiation is streaming towards Earth from the sun, and the alert has been upped from amber to red. I poke my head out of the door of the flat to see if there is a clear sky, but a thick fog has rolled in from the sea and envelops the village. I curse the clouds, but when I look straight upwards I can faintly see stars, right overhead. I realise it's not cloud, but a haar, a cold sea fog rolling in, heavy and damp, from the North Sea, and it is likely to be held within the valley. So I take my camera and set off walking up the road that zig-zags steeply up the hill behind the village, hoping to emerge into clear air. The haar is thick and cold, and smells briny, clings to my hair. The sounds of my breathing and my boots on the road are strangely muffled, as if everything were draped in thick blankets. It's eerie as I puff uphill. Darkened houses loom out of the mist, and the roadway under my feet is only faintly visible as I walk quietly between the hedges.

I keep walking upwards, until I finally emerge out of the fog. Up high, above the mist, the air is clear and utterly still, warmer too. The village, hidden under the thick haar, is just a diffuse orange glow. The sea, far below, sounds strangely loud in the stillness, some acoustic quality of the fog. I look north for signs of the aurora, but the horizon seems dark. Then I start to notice pale streaks across the sky, right over my head. At first I am not sure what I am seeing. I think it could be cloud, but there is a faint luminosity that seems more than starlight. I climb over a gate and into a field and flop down on my back, letting my eyes slide out of focus so I can take in the whole sky. Then I start to see it properly.

A soft shimmering is filling the whole sky from horizon to horizon, sweeping soundlessly overhead. I set up my camera, and as I watch, the swirls begin to brighten, a soft greenish white pulsing right across the sky. I think of my father explaining 'auroral propagation', how the ionisation of the upper atmosphere caused by the aurora can boost amateur radio transmissions and make long-distance communication possible, but the voices that ride the ionised gases sound ghostly, far away, hard to understand. The aurora is streaming ghost-pale rivers, faint as whispers, between the stars. It spans the whole vault above me, reaching upwards into space, too vast to focus on. I lie back on the grass for a long time, under the cold, silent grandeur, and let the whole wide sky fall into my eyes.

When I get cold, I stand up, crank my head right back, and spin like a child in a playground, giddy and laughing under the pale auroral light. Eventually my camera batteries run out, and the aurora starts to fade, so I walk down the hill and drop back into the fog. It is so thick now I can't see anything at all, not even my own feet. But I know when my tread falls on soft grass instead of firm tarmac that I have drifted off course, so can correct myself to stay on the road. I know when I am passing under the power lines that cross and re-cross the road because I can hear the electricity crackle and fizz in the damp air, so much louder than the usual quiet power-line hum.

At last I cross the bridge beside the flat. Below me the indifferent river, the dark matter of its deep water heavy with snowmelt, carries swirls and speckles of white froth on its surface like small galaxies riding its swift current. The

unseen, the unknown, the forgotten, the hidden, sweeps us along in its powerful flow. I came north in winter to think about darkness, and what it could show me, and what I noticed was the light within it, how gloaming tilts between darkness and light, and how this creates colour. The gloaming state, edging into darkness, softening certainties, is a state of not quite being able to see the way ahead but carrying on anyway, with a relaxed and easy swing. Gloaming is an attitude of mind. In a gloaming state of mind you can keep going even though you've no more than a hazy sense of where you're headed. You just go gloaming on through the fog, towards the next step, the next word, the next decision. As the residency draws to an end and my thoughts turn towards home, I feel lighter than I have in a long time.

QUINTESSENCE

The world is the closed door. It is a barrier. And at
the same time it is the way through. Two prisoners
whose cells adjoin communicate with each other
by knocking on the wall. The wall is the thing
which separates them but it is also their means of
communication ... every separation is a link.

Simone Weil

There is a new mildness in the air. I am back in the
city and spring is back too. I'm walking down the
busy main road near my flat, feeling pleasantly humdrum,
daydreaming along the street in the din of the evening
rush hour, enjoying people's faces as they pass by me, the
way they walk differently in this warmer weather, loose-
limbed, looking up and ahead, glad to have winter behind
them. And then something catches my eye right above the
middle of the roadway: a single white pinion feather spirals
down from the sky, set aglow by the sunlight. It catches in
the slipstream of a passing double-decker bus and starts to
helicopter, spinning fast on a vertical axis. It hovers magi-
cally, lit up by the slanting evening sun, and it keeps on

spinning and spinning up there, just above the traffic. Each time it starts to sag a little the airstream from another passing bus or lorry gives its spin a little nudge and lifts it up again. And so it goes on spinning and shining pure white in the sun, among all the noise of traffic and people flowing past. I stop on the pavement to watch it, pinned to the instant by this small surprise, as the feather stays up, white as hope, spinning and spinning. Finally it slows, spirals down, flip-flops once on the asphalt and vanishes under an onrushing car. I walk on, released once again to the flow of the day, smiling to myself.

I am home in Edinburgh, and I have been thinking, again, about the house in Glasgow that is now in my past, the house I lived in when I was young, but never felt like home, the house my parents lived in, that was left behind when they were gone. I have been thinking about the spaces inside this house, and what they contain even now that they are emptied and I will never open and close its doors again. Beneath this house there was a hole that none of us knew about until it was filled. This house was slowly falling apart for years, and then we took it apart even more as we emptied it of our parents' belongings. I have been thinking about how space is empty and full, and about how the universe will go on expanding until, long, long after we are all dead and gone, the stars will no longer be visible to each other and the night sky will go dark again. I have been thinking about how, because anything obvious has already been found, physicists looking for an elusive particle will go in search of its effects on other particles easier to find, knowing it only through its relationships. Or

they look for a fleeting particle's afterburn, the more stable particles it decays into after its brief instant of existence.

In my dead parents' home I went looking for what wasn't visible through what was, through what their lives left behind; an afterburn of clues, marks, traces, objects, the movements of mind we call memory, sometimes just a feeling-tone, a charged space, a mood, a small hollowness in my throat. I have been much in the company of the dead, while clearing and thinking about this house, trying to detect the dark matter of my beloved dead who once lived there, who live in me yet, and perhaps also to look askance at my own death to come, a thought impossible to hold on to for more than an instant. And it turns out that death, my parents', my own, or anyone's, is not really a completion of something. Our lives overlap, each one in succession. The story doesn't have an ending. It just takes another turn.

Happiness moves slowly, a plant turning to the sun. It is gentle, undramatic. It does not draw attention to itself. You hardly notice it has arrived. One day you just look up and realise something has changed. Happiness is humble, unfolding into the everyday; it's in the iridescent sheen that slides across the surface of a soap bubble as I wash up my coffee cup, when, if I am very quiet, I can hear the tiny *pth* as the bubble pops. It's in the water on the underside of a cabbage leaf, rolling silver balls like mercury in the dark green folds when I wash it as I prepare dinner. It's an unspectacular calm, deep in the bones. I am learning how to hold open those moments that come when I am lost in looking, in listening, not trying to change anything or fix

anything or smooth anything away. It's a feeling of being opened up, of tenderness towards the world, towards some specific thing in the world, a sudden awareness of how replete and utterly strange this moment is, this breath, this light, this quiet of your room, this cup in your hand.

It's a quiet kind of subversion, pressing back against the pressure of reality, pressing back against the gathering acceleration of greed, corruption, hatred, loss, all the hardening of these times, when all the wild world seems to be dying and so many do not have a place of safety and rest, and there is no refuge, not really, not for any of us, however much we may look for it through the bright windows of our screens. Perhaps every age feels like the end times. Maybe there is nothing new in this feeling that reality is full of pain and suffering, injustice and degradation, gathering pace, so much, too much to feel it all, so we make ourselves numb. But reality is also and at the same time full of startling beauty. The spinning feather catching the sunlight above the rush-hour traffic. The starling on the rooftop singing a song of car alarms and squealing bus brakes. It feels like a small and necessary act of resistance, the pause to listen to the urban starling's city song, to attend to the careful washing of a cabbage leaf, to the uncountable blades of grass in my local park, each slender blade performing its own Indian rope trick as it lifts itself miraculously towards the spring sunlight.

Space isn't empty. It has energy and charge. The space of the subtle ether, the gap between things, that has for so long been a way for me to think about my mother and my father, has always felt to me as if it were charged with loss

and longing, a desire to understand something that could never be fully grasped, or to reach towards something that was lacking. But the ether feels different now. Something has shifted. What felt like distance and longing now feels like spaciousness and calm. How to be here. How to be with exactly and precisely what is, with the strangeness of a mundane moment in mid-morning and all the unsteady shifts going on inside; anxious, bored, calm, irritated, sorrowful, sleepy, amused, restless, grateful, numb, all of these moving through like weather. My winter in the north has taught me that grief and loss are part of this calm, just as darkness is part of light, and light, of dark. I am calm now, and ready, and I have work still to do. Virginia Woolf wrote: 'The past only comes back when the present runs so smoothly that it is like the sliding surface of a deep river. Then one sees through the surface to the depths.' But, she warns, 'to feel the present sliding over the depths of the past, peace is necessary. The present must be smooth, habitual.' Our beloved, difficult dead, who live in us, settle out when we become still. Then we see that time is not a river but a deep, clear pool.

In this calm, I can see that the house of the past can never be tidied, emptied out, fixed up. It can't be sold on. The keys cannot be passed on to another. In returning to my parents' house to aimlessly finger the piano keys and stare out of the windows I was looking for a mother I could grieve with the proper decorum of tears, as I had my father. But she wasn't there. To find her I need to go back, right back, back to a mother lost in the darkness of pre-memory, before language, back to infancy and toddlerhood, back

into the forgetful space of the unremembered past, to a remembering lodged deep in the cells of the body, in the ancient lizard brain, in the walnut-shaped gland of the fight-or-flight amygdala, in the hind-brain cerebellum that remembers the automatic movements of walking, brushing my teeth, tying my shoelaces, movements my mother must once have taught me, or helped me learn. To catch hold of her I must go angling into this darkly pooled past, where she shimmers like a fish in the depths, to sink myself down among the sediment and wait, calm and open, for her to come.

What my mother did for me then I must remember at some level. How she carried me inside her body, carried me against her body, wrapped me in white waffle blankets, put me to her breast, offered her tender nipple to my hungry mouth, spooned in puréed food, changed nappies, washed me clean, wiped my nose, lifted and carried me and, later, picked me up and kissed my sore knees better when I tripped, taught me to shape words in my mouth, to shape letters on a page. I can't quite see her, but I can hear her, faintly. She is a voice, and a feeling of warmth. She is singing me a slow, sad-sounding lullaby, 'Go to sleep, my baby, go to sleep. They're lighting the windows of Heaven' in her cracked smoker's voice. 'Angels watch over you.' I am hearing it booming in her chest as I lie in her lap with my cheek on her soft jumper, her warm breast beneath it, and I am playing with the heart-shaped pendant she wore, that had an upside-down watch face in the middle of it, and I am sleepy, and she is stroking my hair and singing to me, her precious late-born baby, the longed-for girl

after the two boys, and I feel perfectly safe, so perfectly, utterly safe.

Or this: we are sitting on the floor at a low table, eating buttered toast. My father and brothers have gone off to work and to school. We have not long moved into the house and we are camping out in the upstairs bedroom while my father demolishes the huge brick fireplace in the basement with a sledgehammer. It is a big, bright room with tall windows at the level of the top branches of the larch tree in the front garden. The sun is shining, its light filtered by the feathery larch needles, and we are eating together, my mother and I, and she is mine, all mine. All day it will be just the two of us and I do not have to share her, and this is perfect, sitting on the floor eating hot toast and soft-boiled eggs with my mother, with the sunlight coming in through the branches of the tree and dancing as it falls across the floor.

She is a voice. I am standing at the basement windowsill, which is deep-set with a wide shelf, and I am absorbed in some activity there, drawing perhaps. My mother is talking with a visitor, a woman friend, saying, 'Yes, she's very quiet really', and I realise that she must be talking about me.

She is the sound of the piano, played carefully but a little unevenly. Sweet-sad music that gives me feelings I can't name. The gas fire hissing softly.

She is a red shiny raincoat with flat brass buttons like coins. I have a raincoat the same colour, but mine has fancy clasps and a fur-trimmed hood. When we both wear our bright red raincoats and walk down the street together I hold her hand and feel proud.

She is long fingernails painted frosted raspberry pink.

She is fingers stroking my hair as I lie with my head in her lap, feeling sleepy, in the narrow wooden pew of the big stone church while Father Reid gives his sermon. I like to stay with her here, not go to Sunday school with the other children. I like the churchy smell of candlewax and chrysanthemums. I like the way Father Reid's warm tenor voice rings among the stone columns as he sings the liturgy of the Scottish Episcopal Church, or reads out the beautiful cadences of the King James Bible. I like the sound of the words we say together. Thee thou verily. Holy catholic and apostolic. Eucharist and evensong.

When my brothers and I came to my mother's hospital bed that evening to tell her that our father had just died in another ward, when my brothers finally readied to leave I told them I would stay and just sit with her a little longer, so we didn't all leave her at once, alone with this news among strangers. I was not sure she had fully understood what had happened, if it had sunk in. I was too exhausted to say much. I had come from a day and a night and a day at my father's bedside, taking turns with my brothers to watch him as he dug his way slowly under, breath by breath, listening as his lungs clogged like a ditch, as if he were sinking slowly into a bog, holding his hand that was now puffed and smooth as a baby's, stroking his clammy forehead, until that last long breath bubbled up like a muddy geyser, an unmistakable rattle that echoed right down the long Victorian ward, and death wrung him out like a wet cloth.

Once admitted to hospital it seemed that my father

finally let go of something and allowed himself, at last, to be looked after. But he was already very sick by then, and his condition deteriorated within days. Over the last twenty-four hours or so he had slipped beyond speaking, his face slackening and his eyes swimming in and out of focus. He was leaving us. At one point during the night, as I sat vigil with him, watching him drift in and out of sleep, he seemed to waken fearful and confused. I held his hand, and leaned in close to find his gaze and reassure him, 'It's okay, I'm here. It's okay.' His eyes found mine and came into clear focus. He was there with me again, right there, looking directly into my eyes in a way he never had before. It was like I saw right into him in that moment, and he into me. It was as if all the love and sadness of all the long years, all that we had never talked of but both understood, all his regret and tenderness for me and mine for him, all the things he had never been able to say to me nor I to him, here it all was now, pressing upwards and out of him, as if something huge and powerful were swimming up from a tremendous depth to meet me, rising up to breach the surface for one shining, wordless moment of love, sorrow and leave-taking. Still holding my gaze, my father sank away from me again, the life in his eyes dulling and becoming quiescent. It didn't come back.

My brother came to join me from visiting our mother and we sat together quietly close by our father's bed. Over the next few hours his breathing became shallower and shallower, his skin greyer and his face slacker, and then, out of such an imperceptibly slow sinking, came a vast sweep like a sudden wind, that rushed through and out of

him in one long expulsion, and he was gone. There was no ambiguity. The nurses came quickly, knowing the sound, slipping through the curtain they had drawn around us for some privacy on the long ward when they could not find us a room. They hugged us with real warmth, their eyes wet.

I had, in the end, been glad not to be shut away in a small room, glad that as we sat with my father the day-to-day world of visitors and ward rounds was still going on around us on the other side of the curtain, that, even at the bleariest hour of the night, the nurses' station was just two steps away if my father seemed distressed or in pain. Later, as my brother and I left our father's bedside and walked down the ward together carrying away his small bag of possessions, the jacket that still smelled of him over my arm, we saw a grey-haired couple sitting side by side on a bed opposite, holding hands, their faces solemn, reverent. The woman's eyes were red and wet. They knew that something sacramental had just happened, a man had died, a few feet away from them, just behind a curtain. My brother looked at them, smiled weakly, said, 'It's okay, really. It was okay.' And it was. My father's dying was slow and toiling. But the moment of his death itself felt as if something huge and holy had moved through us all, as if we had received some kind of gift, an unexpected moment of grace.

That evening, dog tired and emptied out, my cheeks strangely hot, I held my mother's hand in silence, not sure what to say. She lay in her bed in a ward at the other end of the same big city hospital, lying back quietly on her pillows while other elderly women around us talked to themselves

in various states of confusion and agitation. She held my hand meekly, giving one-word answers.

Out of a long silence she said flatly, 'I can't cry.'

Taken aback I asked, 'Why not?'

'The pills.'

And with these two words I knew that she had been there all along and I was not looking, and I did not help, that she had always known what had been taken from her, what she had lost, what we had all lost. Gone were all the wild fruits of her unruly, thicketed mind, her unfenced, reckless, ravenous heart, all her holy bewilderment and the brazen, self-willed, downright bloody-minded inconvenience of it. Gone were the angels in the walls speaking with voices like the fluttering of wings, and the radiant, godly light pouring into her from all sides. Gone too the feral rapture, the divine panic in full flight, its wings spanning abyssal skies with boundless, outrageous, ferocious love that burned me like a heretic and set her pacing at the school gates in wait for me, even as I fled from her and ran home before she saw me, afraid of her, afraid to be seen with her, ashamed of her, ashamed of myself.

I had been wrong. My mother's ether was not just a soporific hiding place of numbness, a cold and silent expanse of empty space. It was not only the ether of stupor, anaesthesia, lobotomised dullness, her endless sleeping, but also another ether, the ether of a burning holy glory, unseen and always present, just a breath behind the seen world. My mother's hand was always reaching for the Celtic cross pendant she wore, a gift my brother had brought her from Iona, finding some reassurance in its touch as her lips

moved soundlessly in prayer. Doesn't ethereal also mean heavenly? From the ancient Greek *to atheiron*: of or pertaining to the upper air, celestial, spiritual, marked with unusual delicacy or refinement. To the four classical elements of earth, air, fire and water, Aristotle added his fifth element, the *quintessence*, ether. Aristotle's ether filled all of space behind the moon all the way out to the celestial sphere onto which the stars were fastened. Its etymological root *aithein* means 'to burn' or 'to ignite'. His stars basked in a fire that was never snuffed out. Unlike the four terrestrial elements, which were subject to change and moved linearly, Aristotle's ether moved in eternal circles, holding the celestial bodies in perfectly circular orbits.

Medieval scholastic philosophers like Robert Fludd described the character of the ether as 'subtler than light'. Filling the 'middle sky' between the outer heavens and the inner space between the moon and Earth, Fludd described the ether as 'that very beautiful matter, whose shining soul is prepared to satisfy the desire of its spiritual material, and preserve it from change and decay'. It was 'the bright essence gushing in endless numbers of small streams from the original supercelestial spring into every part of that celestial sea, as the ancients called the Ether'.

'It displays,' he wrote, 'the forms of both highly rarefied water, and of waters and mist vapours, never still ... We call it the container, binder and vehicle for the Soul of the World ... by whose action a natural and vivifying heat is stirred up, it is called Ether, that is Shining, for according to Isadore, it is perpetually bright and clear; or it is called fiery, according to Anaxagoras, who said that all that

burns should be called Ether, for the Ether is nothing but the air on fire, which in Greek grammar, is derived from *aitho* which means "I burn"; the spiritual atmosphere is, as it were, burning spirit.' In other cultures, my mother might have been thought a shaman, a spiritual healer, one with a special gift of sensitivity who could receive messages from other realities, hidden worlds, spirits with urgent messages for the rest of us. She would have been helped to listen to the voices that spoke to her and no one else, taught not to be afraid of them, to decipher their meanings, to convey their messages. As it was, my mother's burning spirit burned her up. All those who had loved her were scorched by its fire.

I squirm in my seat as I try to write about my mother. My fingers hover and hesitate, twitching above the keyboard as if feeling for her in the air above the keys. My mind skitters away like a stone across a frozen pond. I keep getting up from my chair: to empty the washing machine, to make some more coffee, to open the fridge and stare inside it. I sit down again. I check emails, decide I need to look something up online. I have to force myself to focus, to continue this fingertip search for my mother. She was the immovable central fact around which everything else in my life had to revolve, around whom everything had to be adapted. And yet she wasn't really there. In death as in life, she is at the same time far too close and too far away, needy and infuriating, gentle and stone-hard, unreachable and suffocating, always everything in together in a way that never settled down while she was alive and will not now resolve into clean grief.

I stand up and go through to the kitchen, forget what I meant to do, come back and sit down at my desk. I go on trying to place words as close as I can to this subtle sadness, this lifelong companion, the shape of days and years and the colour of the spaces between the busy outward-turning hours, when softly she comes in to me all frightened and difficult, my mother, whom I could not love, did not love, did love, loved badly, loved with thick gloves on, handling the loose change of our daily life so clumsily, dropping pennies and missing moments when I might have touched her, spoken, opened. I have to force myself to stay here, deep inside this uncomfortable dull restlessness, feel how it keeps pressing at me in new places to get a response. I try to sit still and watch it, make room for it, all of it. I set a timer and make myself sit and write for an hour without getting up, without pausing. I move my fingers over the keyboard, half-blind, digging on through repetitions, self-pity and cliché, patiently brushing away the layers, down here among the potsherds and old bones, doing my archaeology.

And then, suddenly, I see her, a clear memory coming up as sharp as a slap, and I can hardly bear to keep looking. She is eighty years old and my father is supposedly caring for her, but he too is failing. Everything has been slowly falling apart for years and I don't know what to do. My mother has just woken from a drugged sleep and sits forward, staring dull-eyed at the television, face slack, mouth hanging open, her badly fitting false teeth dropping in her gaping mouth as she yawns and yawns and yawns again as if to dislocate her jaw. She fidgets, sits forward,

sits back, sits sideways curled up tight, sits forward, sits back, until my father, exasperated, snaps at her: 'Keep still, will you!' They hardly speak to each other. My mother sits forward again, chewing her mouth, trying to contain her restlessness. She reaches for a cigarette and smokes it all the way down without moving, until the long column of ash droops and crumbles under its own weight. Her blouse is stained with food and perforated with cigarette burns, her trousers are dirty and falling down at the back. Her unwashed hair is stuck to the side of her sleep-creased face. Her fingernails have grown so long they have begun to curl around and she can hardly hold cutlery. 'Will you cut my nails?' she asks. I know I have to cut them. She can't do it herself any more and neither can my father.

I ask her to come and sit at the table where I can see better. She rises slowly to her feet and shuffles across the carpet, stooped over almost double, grabbing at chair backs and table edges to steady herself. Sometimes she just stops in her tracks, as if she has forgotten why she is standing, or can't remember how to move her legs. A few years ago, she had started to say that her legs didn't always do what she wanted them to. This kind of dyskinesia is a side effect of taking anti-psychotic drugs for a long time. My father says, dismissively, 'It's all in her head.'

She makes it over to the table and sits on the chair awkwardly, half on, half off, until I help her straighten up. I switch on the light to see better and she puts out her hand expectantly. I don't really want to do this. I take the clippers from their pouch and it feels like I am reaching across an abyss as I take her hand. Her fingers are stained brown

with nicotine and dark gunk is packed under each nail. I scoop each one out. She has such tough, horny fingernails even now, hard to cut, and it is easy to nip her, as the nail beds grow right down to her fingertips. I perform the task without comment, carefully, but without tenderness. She watches me work. One by one I clean and trim her nails. I have not touched my mother for years. Her hand is so soft. It is my mother's hand. I am holding my mother's hand. I have not held this hand since I was a child.

She is not dim now and I am not blank. I can see her clearly and as I go on writing down the words that come I rock in my chair with pain and shame. To place her like this here, exposed and undefended on the page, seems like one last cruelty. This is not all she was. But I need to look at her, like this, at her lowest, at our lowest, to really see her, and myself, and to keep looking until something hardened in me begins to fall away.

When we wheeled our mother that afternoon into the quiet of the ward's day room to tell her the news of our father's death, her first thought was not for her own loss, but for ours. She looked into my brother's eyes and said, emphatically and without a trace of irony, her Durham accent strong as ever: 'At least you've gorra healthy mum!' She remained in hospital for a further three months, and accepted this uncomplainingly, though the ward was noisy, full of elderly women with various degrees of dementia. An alarm beeped loudly whenever the woman next to my mother rose unsteadily from her bedside chair to wander down the ward in search of her son, her handbag or her house keys, and a nurse would have to come and gently

usher her back to her seat. The woman in the bed directly opposite my mother's seemed perpetually furious, swearing at nobody in particular, hitting out at auxiliaries sent to sit with her to try to keep her calm. A tiny, bird-like woman in a separate room near the nurses' station shouted tirelessly from her bed, 'Nurse! Nurse! Nurse! Help! Help!' in a raucous voice that echoed down the ward all day long.

Amongst all this noise and activity, my mother lay back quietly, propped on pillows, floored by a chest infection, speaking little, grieving quietly and inwardly. She was very weak at first, grey around the lips in spite of the oxygen feed at her nose. For a while we wondered if we might lose her too, that she would quickly follow my father, as long-married spouses have been known to do. But, clean and warm and well fed, with attention from the kindly nurses, activity all around her, and daily visits from me or my brothers, she began to brighten. When we to spoke to her about the future, about possible care homes, she accepted our suggestions mildly, showing no inclination to return to the family home without my father there.

When finally everything was arranged, we moved her to a nursing home where she would be safe and cared for twenty-four hours a day. Once she had been moved to the home, as the weeks passed, I still missed my father painfully, but was also aware of something lifting, a quiet sense of relief slowly stealing over me. My skin, after years of painful acne had left my chin a disheartening mess of scars and bumps, miraculously cleared by itself overnight, my face smooth and unblemished for the first time in years. I slept well, managed to see more of my friends. Life

opened up again. After a long period of being single and too preoccupied to do much about it, I met someone, and a new relationship began that continued to flourish with unexpected ease and lightness.

Under the smiling kindness of the staff at the nursing home my mother began to reawaken. The nurses and care assistants chatted and fussed over her. She was grateful and uncomplaining and ate up all her meals, told them 'I like it here!' The staff loved her for this, and fussed over her all the more. She was washed daily and dressed in fresh clothes, her hair done in curls. They even painted her nails for her. She took part in the art and music activities the home laid on. A new GP adjusted her medication and she became more alert and communicative. For the first time in years, she began to volunteer whole sentences. A gentle sweetness re-emerged from her.

No longer harassed by her repetitive, pointless phone calls, my brothers began to visit her more often than before, willingly, bearing small gifts, hand-feeding her sweet treats. I saw how they both started to come unclenched, softening visibly, smiling at her, showing affection. I watched as she beamed with pleasure when they walked in the room, knowing I didn't get quite the same smile of greeting, knowing I didn't give her quite the same smile back. Did she choose to ignore my birthday and not theirs, I wondered, or did she just forget? I watched her eyes go to them and light up with joy, and felt an old grief rising in me, a childish jealousy; she loved them more than me, I was a bad daughter, selfish and wilful, not the devoted, affectionate daughter she had wanted. I would hold her clean, soft hand and smile at

her, and I did not know why I still could not quite hold her gaze, why I was hurt and also a little relieved when her eyes slid past me as soon as one of my brothers appeared. I held her hand and I smiled at her just as they did, but it was not straightforward affection I was feeling. It was something much more tangled.

Her death was quiet, snowfall on salt water. She seemed to go willingly, almost nonchalant. A chest infection in her damaged smoker's lungs turned quickly to pneumonia and she was gone. In the dim hush of the night ward my brothers and I stood around her bed in a pool of lamplight. I removed her rings one by one, slipped the watch from her wrist, dropped them in the envelope the nurse brought, uncurled her cooling fingers and pressed them flat upon the white bedclothes. My brothers covered their wet faces with their hands, their shoulders shaking. But I did not weep. I felt a hushed stillness, a chilled wonder, like I had stepped that night through an open door and out into an unseasonal heavy snow.

Later, back in the old house, I laid out her clothes, smoothing her coats on the bed. Her blouses, pink and lavender, draped on the chair back, I lifted and folded away. I folded her things away, though they were stained and old and full of holes, because in that time just after her death I was not sure what else to do. And so I go on, still folding her things away, her old, stained things, folding them away for safekeeping and saying thank you, thank you. For all of this dark love I will go on saying thank you.

*

Mothers are inside daughters are inside mothers. I was born the day my mother was newborn, lodged as a tiny seed that grew inside her ovary as she grew inside her own mother, as my unborn daughters were born with me at my birth, an infinite regress of Russian dolls. My mother burns far away, like the ether beyond the moon. And my mother burns inside me, passes right through me like the ether wind, yet still I cannot find her, cannot measure her drift. Inside me lives an old fear, a gift from my mother, her legacy to me. But it is not a wound. It is not a fault to be fixed. It is an enrichment, the texture of my life, the last I have of her, the thing we share, this fear that has no reason, needs none, fear that grinds along my bones and lodges just behind my throat, that wakes at dawn and stretches itself and turns over in me. As so many have looked for and failed to find the subtle ether, I've been looking for my love for my mother, as if there might be something clean and straightforward under the sediment of sorrow and anger. Not the woman my brothers grieved, the woman they tell me was beautiful, vivacious, musical, loving, but the anxious, needy, over-medicated woman I knew. She is buried deep in me, lives in my body, this same body that was once inside hers, her body that lives on in mine, in the hands that look so much like hers, in the dark brown eyes and hair she gave me.

I find her, close by my heart, here, in the fear that lives in the crawlspace behind my ribs when I wake at 4 a.m. with a mind ablaze, flickering with fast-edit images of vivid dreams that leave a choking sensation. I try to breathe with it, anchor my flailing mind on the steady, rocking

rhythm of the breath, until I feel a space open up around the fear. I take a deep breath to ease the tightness in my chest and turn my cheek to a new, cool side of the pillow, some new arrangement of limbs to distract my mind for a few moments, and then it is back. There is room for all of it, this too, even this difficult, old friend. Fear, rising in me like an ancient pike, its mouth full of hooks.

POSTSCRIPT

From my window I have been watching long skeins of greylag geese fly in over the loch in the slate-grey afternoon light, as they leave the wet winter fields they have been grazing all day to gather and roost for the night. They shimmy as they tip the air from under their wings to lose height faster, splashing down with a commotion of honking and flapping, to join in noisy parliaments and finally settle over the loch in scattered flocks. The wind's been picking up steadily in the last couple of hours and now it's a howling winter afternoon. The sun has long since gone down. Outside the darkness roars, and now and then the windows rattle with hailstones. The stove whistles and thrums as the gale sucks hard at the chimney. I wedge another log in, clamp the stove door shut and the flames take hold and warm the room.

I am coming home, to a new home, to Orkney. I am learning this land of clean, plain lines, this grey sea thumping at the cliffs, this wide, roaring sky full of wind and cloud and rain and slanting silvered light. There is a lot of sky here. And a lot of water, both salt and fresh. The loch

beside the house is a bowl of light rimmed by grassy hills. In early summer everything is blue and green and silver. Then, the long grass sparkles like waves as the glossy blades bend in the wind. Brown hares come to nibble dandelion flowers and wash themselves like cats in the sun, and the bright summer air tastes effervescent, filled with the calls of curlew and lapwing, and the roaring of the neighbours' bulls as they face off across the burn.

Summer and winter, the wind is a daily presence. On gusty mornings when I cross the yard from my front door to my studio it blows the coffee out of my cup and sends my toast flying. Each wind direction has its own character and mood. Westerly is a brawling bully with the heft of the North Atlantic behind it, bringing salt that brines your lips, shrivels the flowers and fogs the windows until the next rain washes them down. An easterly gale comes in raw, bashing up the frothing loch to hurl itself into the big sitting-room window until you can see it bow under the weight. It swirls round the yard, thrashing every plant ragged and tipping over pots and chairs. Northerly has a sharp edge, needling into every seam of clothing, between the stitches of the thickest jumper, down every gaping cuff or neckband. Southerly makes the stove burn fickle, yanks the car door from your hand. Calm days lie softly over the loch, a rare gift of silence. Then, the water fills with sky, its mirrored surface dimpled as trout rise to feed on hatching flies.

This house hunkers down close to the loch shore, cosying low to the ground among a companionable huddle of sheds and old cow byres. I hunker down here too. I am quietly growing my way down into this ground, along with the kale

and onions I've planted in the lee of the stone dyke, and feel no particular craving for gentler climates or brighter suns. They say the long, dark winter here can break you if you're not used to it, but I don't mind the darkness, and I'm making my peace with the wind. I know the payoff will come in summer when we'll be drenched in breezy light for months.

Bedded into the land all around are stones that speak of layered time and endless change: a single upright standing stone, its flanks rubbed dark by centuries of moulting cattle; the ruined palace built by the robber-baron bastard son of a Stuart king, its chimneys still standing tall, but weathered now like sea stacks; the neatly mowed remains of a Norse monastery on a grassy outcrop that cuts off at high tide; a wartime airfield control tower watching only grazing cattle now; the rubble of an Iron Age broch poking through rough pasture; a nineteenth-century watermill, its millstones still turning; a deserted village six thousand years old; two cemeteries, one loamed with centuries of parish dead beneath lichened headstones, another with freshly lettered stones and lairs awaiting; farms whose names tripped off the tongues of Picts, then Norsemen, then Orcadians, and now my own incomer's tongue. All these are within walking distance, or even visible from the house. So many lives overlapping, rising and falling one after the other, like waves, change and change and change. Only the worn stones remain.

When I have been away for a while, and I come over the last hill for home, the wide silver platter of the loch opens out ahead of me and the sea beyond it also rises into

view. From here you can see that the narrow rim of land on which my new home is nested is just a strip of pasture, a mile or so wide, between the fresh and the salt water. It seems like a frail strand of green that might just snap one day. Then the sea would rush over our neighbour's silage field and lift his black Angus cattle and his rusting tractor, lift our house, our neat rows of leeks, our rag-tag collection of sheds, sweep the whole lot away leaving just another rubble of old stones behind to poke through the grass. My feeling of homecoming, of tipping the air out from under my wings to arrive and settle here, this sense of quiet contentment, is not permanent, I know. I am daily reminded, by the remains left by those who have come and gone from this island before me, that nothing ever is. The news I read by day grinds into me in the wee small hours. Unwelcome change will surely come, like a gale, thumping into the rocky shore and washing over the fields and cattle sheds, or like a spring tide's flood, creeping stealthily. But for now, I tend my wood burner, answer messages from online students who may live on the other side of the world, heap seaweed on the vegetable patch, hoe the leeks, fill potholes, and draw, and write. For now, at times, I can't quite believe my luck. The sale of my parents' house made possible leaving full-time academia for something less all-consuming that doesn't require commuting to a city campus, which in turn made possible the move to this house between loch and sea. My parents' final gifts to me: a desk beside a thrumming stove, a window onto open sky and bright water, and time.

I have been working on a drawing, in stops and starts,

since my parents' house was sold. I rise from my desk, stretch my aching hand, pin the last panel in place and step back to see if it really is finished. It's big, the biggest drawing I've ever done, made in sections that when pinned up together take up a whole wall of my new studio and reach from floor to ceiling. I have been working on it for more than three years, picking it up between other tasks, between writing and teaching and finishing a doctorate, leaving my old job and starting a new one, and moving to Orkney to make a new life here with my partner. This drawing has made the journey with me, kept me company along the way, fitting into any crack or gap that opens in the day, a task that has settled me each time I sit down to it, no matter what else has been going on. It has been a long, quiet, meditative task, unhurriedly drawing thousands upon thousands upon thousands of tiny circles, like water bubbles, each one white on a black ground. The drawing that now fills the wall is the result of hundreds of hours of repetitive rhythm, drawing circle after circle, like a visible incantation I have repeated again and again, *now* and *now* and *now* and *now*, until all these fleeting instants begin to gather in foamy swirls like froth on the surface of a deep river pool. I have been writing too, a story of my father and my mother and the subtle ether, pinning moments down in rows of letters, rows of words, line after line of them, telling of *then* and *then* and *then* and *then*. I have tried to tell what I remember, but the story is fragmentary, full of gaps and faulty memory. Most of it will stay unremembered and unwritten, the unseen current of time flowing beneath the surface of events and words. This drawing has been a companion piece to the

writing. I think it might be finished now too, but I'll leave it up a while, see how it looks tomorrow.

The other night I dreamt about my mother, the first dream of her I've had in a very long time. I was walking alone down a busy street when I saw her walking towards me. It was definitely my mother, but as if she had had an entirely different life, one in which she had never become ill, in which she had a different husband, job, family, and lived a life in which she had truly flourished. She was in her sixties perhaps, well groomed, bright eyed and upright, dressed in elegantly tailored clothes and walking confidently along the street, occupied by her own business. I was happy for her, pleased to see her looking so well and prosperous, and greeted her warmly. She didn't recognise me of course, because in this dream I had not been born to her, but she submitted graciously, if a little bewildered, to my effusive hug. And then we both carried on our ways.

From here I can look across the yard and see the sitting-room window's warm glow. Over in the house, Andrew will have finished his own day's work and logged off by now, maybe made a pot of tea. In a moment, I'll close the stove down to dying embers, turn out the studio light, step out into the chilly dark pulling my scarf tight about me, and hurry across the blustery yard to join him.

ACKNOWLEDGEMENTS

I have been lucky enough to receive advice, encouragement and support from many generous fellow writers in the years it has taken me to write this book. In particular I am grateful to Jay Griffiths, who heard me first blurt out that I wanted to write a book about the spaces between things, and whose enthusiastic response made me take the proposition seriously. I am also deeply thankful to John Burnside for his patient support and encouragement as it slowly dawned on me that this was actually a memoir about my parents. Thanks also to Richard Kerridge, Peter Mackay, Ian Marchant, Alison Hawthorne Deming, Jonathan Callan, Marion Roach Smith, David Manderson and Martin Toseland for advice on various bits and stages of draft, and for encouragement along the way.

I am grateful for the support of Timespan Arts and Heritage for my three-month residency in Helmsdale, and to the Scottish Book Trust for the New Writers Award that helped me complete the manuscript. Both of these bought me some precious time to write. Thanks also to the Arvon Foundation at Totleigh Barton, where I spent a week working on an early draft.

Thanks are due to my tireless agent Jessica Woollard at David Higham Associates, and to my rigorous and insightful editor Ailah Ahmed, and her colleagues at Little, Brown.

Thank you to my dear brothers Mark and Paul, who have walked beside all this long way, and without whose love and encouragement I could never have brought this book to publication.

Thank you to Andrew Woodward, for everything, always.

Most of all, I am grateful to my parents, Allan and Wynne. I owe them everything.

Early versions of parts of the manuscript were first published in the pamphlet *Dark Matter*, published by Timespan Arts and Heritage; in *Dark Mountain* issue 9, 'The Humbling'; and *New Writing from Scottish Book Trust New Writers Awards* volume 10.

BIBLIOGRAPHY

Asendorf, C. (1993) *Batteries of Life: On the History of Things and Their Perception in Modernity*, Berkeley and Los Angeles: University of California Press

Bachelard, G., trans. E. R. Farrell and C. F. Farrell (1943) *Air and Dreams: An Essay on the Imagination of Movement*, reprint, Dallas: The Dallas Institute Publications, 1988

Bartusiak, M. (1993) *Through a Universe Darkly: A Cosmic Tale of Ancient Ethers, Dark Matter, and the Fate of the Universe*, New York: HarperCollins

Berry, W. (1998) *The Selected Poems of Wendell Berry*, Berkeley: Counterpoint

Bogard, P. (2013) *The End of Night: Searching for Darkness in an Age of Artificial Light*, London: Fourth Estate

Bortoft, H. (1996) *The Wholeness of Nature: Goethe's Way of Science*, Edinburgh: Floris Books

Bose, J. C. (1927) 'Adrisya Alok (Invisible Light)' in *Collected Physical Papers*, New York: Longmans, Green and Co.

Brunnholzl, K. (2012) *The Center of the Sunlit Sky:*

Madhyamaka in the Kagyu Tradition, Boulder: Snow Lion Publications

Bucciantini, M., M. Camerota and F. Giudice, trans. C. Bolton (2015) *Galileo's Telescope: A European Story*, Cambridge: Harvard University Press

Carroll, S. (2012) *The Particle at the End of the Universe: The Hunt for the Higgs and the Discovery of a New World*, London: Oneworld Publications

Constable J. (1821) 'Letter to Rev. John Fisher' as quoted in Friedenthal, R. (1963) *Letters of the Great Artists: from Blake to Pollock*, London: Thames & Hudson

Davis, N. (2016) 'Milky Way no longer visible to one third of humanity, light pollution atlas shows', *Guardian*. Available at https://www.theguardian.com/science/2016/jun/10/milky-way-no-longer-visible-to-one-third-of-humanity-light-pollution

Doty, M. (2000) 'Souls on Ice'. Available at https://www.poets.org/poetsorg/text/souls-ice

Garfield, J. L. (trans.) (1995) *Fundamental Wisdom of the Middle Way: Nāgārjuna'sMulamadhyamakārikā*, Oxford: Oxford University Press

Harman, P. M. (1982) *Energy, Force and Matter: The Conceptual Development of Nineteenth Century Physics*, Cambridge: Cambridge University Press

———— (1998) *The Natural Philosophy of James Clerk Maxwell*, Cambridge: Cambridge University Press

Hooke, R. (1665) *Micrographia or Some Physical Descriptions of Minute Bodies*, reprint, New York: Cosimo Classics, 2007

Hooper, D. (2006) *Dark Cosmos: In Search of Our*

Universe's Missing Mass and Energy, New York: HarperCollins

Huffmann, W. H. (ed.) (2001) *Robert Fludd: Essential Readings*, Berkeley: North Atlantic Books

Jullien, F. (2011) *The Silent Transformations*, Chicago: University of Chicago Press

Kahn, D. (2013) *Earth Sound Earth Signal: Energies and Earth Magnitude in the Arts*, Berkeley and Los Angeles: University of California Press

Kalmeijer, R. (2006) 'Mother Nature's Radio'. Available at http://www.robkalmeijer.nl/techniek/electronica/radio-techniek/hambladen/qst/1994/01/page49/index.html

Lilburn, T. (1999) 'Slow World' in *To the River: Poems*, Ontario: McClelland & Stewart

Leake, C. D. (1925) 'Valerius Cordus and the discovery of ether', *Isis*, 7:1, 14–24

Martin, A. (1992) *Writings* Ostfildern-Ruit: Hatje Cantz Verlag

Michelson, A. A. (1903) *Light Waves and Their Uses*, Chicago: University of Chicago Press

Miller, D. (ed.) (1995) *Goethe: The Collected Works, Volume 12 – Scientific Studies*, Princeton: Princeton University Press

Milutis, J. (2005) *Ether: The Nothing that Connects Everything*, Minneapolis: University of Minnesota Press

Niven, W. D. (ed.) (1890) *The Scientific Papers of James Clark Maxwell* (2 vols), New York: Dover Publications. Available at http://strangebeautiful.com/other-texts/maxwell-scientificpapers-vol-i-dover.pdf

Panek, R. (2011) *The 4% Universe: Dark Matter, Dark*

Energy and the Race to Discover the Rest of Reality, London: Oneworld Publications

Priesner, C. (1986) 'Spiritus Aethereus – Formation of ether and theories of etherification from Valerius Cordus to Alexander Williamson', *Ambix*, 33:2–3, 129–52

Seamon, D. and A. Zajonc (eds) (1998) *Goethe's Way of Science: A Phenomenology of Nature*, Albany: State University of New York Press

Snyder, L. J. (2015) *Eye of the Beholder: Johannes Vermeer, Antoni van Leeuwenhoek, and the Reinvention of Seeing*, London: Head of Zeus

Stevens, R. G. and M. S. Rae (2001) 'Light in the built environment: potential role of circadian disruption in endocrine disruption and breast cancer', *Cancer Causes Control*, 12:3, 279–87

TimeandDate.com. Available at http://www.timeanddate. com/astronomy/different-types-twilight.html

Weil, S. (1952) *Gravity and Grace*, reprint, Oxford: Routledge Classics, 2002

————, ed. S. Miles (2005) *An Anthology*, New York: Penguin Modern Classics

Woolf, V., ed. A. O. Bell (1980) *The Diary of Virginia Woolf, Volume III 1925–30*, London: Hogarth Press

Wright, M. R. (1995) *Cosmology in Antiquity*, New York: Routledge

Zajonc, A. (1993) *Catching the Light: The Entwined History of Light and Mind*, New York: Bantam

Zeilinger, A. (2010) *Dance of the Photons: From Einstein to Quantum Teleportation*, New York: Farrar, Straus and Giroux

CREDITS

CREDITS